**Development
Manager**
Isaac Slone

Advisory Group
Michael Diamond
Marilyn Kohn
Karen Kornblum
Jaime Levine
David Neuwirth

:tion

Funding has been provided by the American Psychoanalytic
Foundation through the American Psychoanalytic Association.

Contributors

Dana Brotman is a painter whose work is shown regularly at Touchstone Gallery in Washington, DC. Her most recent solo show, *Transitional Spaces*, was a series of paintings that explored liminal spaces. The show, scheduled to open on March 13, 2020, was already hung when the gallery space was shut down due to COVID restrictions (the show was moved online). Other shows include her 2017 solo show *beg borrow + steal: works on cardboard*, the 2016 group show *Figure 8+1*, the 2014 group show *Form Transformed: Five Sculptors*. In addition to her work as a painter and photographer, she practices clinical psychology in Falls Church, VA.

Luca Caldironi, MD, is a clinical psychiatrist and a member of the Italian Society of Psychoanalysis (SPI), the American Psychoanalytic Association (ApsaA), and the International Psychoanalytical Association. He is a professor at the Martha Harris School of Psychoanalytic Psychotherapy in Bologna, Italy, and he has been a lecturer at the Padova University, Department of Philosophy, Sociology, Pedagogy and Applied Psychology (FISPPA). His publications and presentations emphasize Bionian thought, especially around the concept of creativity, which he also incorporates as director of the Venetian art exhibition space Castello925. His "K-Now-L-Edge" project is devoted to the study of creativity and its development between art and psychoanalysis and in clinical work. He has a private practice in both Modena and Venice and holds individual and groups consultation in New York.

Paula Coomer grew up in the industrial Ohio River town of New Albany, Indiana. The daughter of more than two hundred years of Kentucky Appalachian farmers, she moved to the Pacific Northwest in 1978. She has been a migrant farm laborer, a waitress, a bean sorter in a cannery, a cosmetics saleswoman, a federal officer, a nurse, and a university writing instructor. Her essays, short fiction, and poetry have appeared in *Gargoyle*, *Ascent*, and *The Raven Chronicles*, among others. Books include the novels *Jagged Edge of the Sky*, *Dove Creek*, *Summer of Government Cheese*, the Blue Moon health and wellness series, and two poetry collections: *Nurses Who Love English* and *Devil at the Crossroads*. Coomer was nominated for the Pulitzer, the Pushcart, and other awards. Her newest book, a collection of short fiction, *Somebody Should Have Scolded the Girl,* is a BuzzFeed-recommended title. She lives in eastern Washington State, where she teaches and promotes writing in the community.

Kelly Cressio-Moeller is a poet and visual artist. Her poetry has appeared in *Crab Orchard Review*, *Gargoyle*, *Guesthouse*, *North American Review*, *Poet Lore*, *Radar Poetry*, *Salamander*, *Southern Humanities Review*, *THRUSH Poetry Journal*, *Valparaiso Poetry Review*, *Water~Stone Review*, and *ZYZZYVA* among others. Her debut collection, *Shade of Blue Trees*, is forthcoming from Two Sylvias Press. She is an associate editor at Glass Lyre Press.

Gail Griffin is the author of four books of nonfiction, most recently *Grief's Country: A Memoir in Pieces*, named a Michigan Notable Book, and *"The Events of October:" Murder-Suicide on a Small Campus*. Her essays, poems, and flash nonfiction have appeared widely and been honored in publications including *Southern Review, Fourth Genre, Missouri Review*, and *New Ohio Review*. A native of Detroit, she spent a long career teaching literature, writing, and women's studies at Kalamazoo College, where she won awards for both teaching and creative/scholarly work. She is at work on a collection of personal essays on confronting whiteness; she is also digging through a stack of paper to see if a poetry collection is hiding there. From her vantage point in southwestern Michigan, she studies, and mourns, the cracking open of America and dreams of her next trip to the shore of a Great Lake.

Gjertrud Hals was born and raised on a small island on the northwestern coast of Norway. Much of her artistic work is an attempt to express the connection between the island's micro-history and the world's macro-history. She was educated as a tapestry weaver; however, she soon started experimenting with other techniques. Her

breakthrough came in the late 1980s with Lava, a series of one-meter-high urns made of cotton and flax pulp. These vessels marked her transition from textile to fiber art. She makes objects that vary in nature and in the techniques applied: casting, spraying, cutting, knitting, and weaving. She enjoys creatively acting as she pleases, using whatever material she wishes, being severe and meditative one day and playful the next.

Adrienne Harris, PhD, is faculty and supervisor at New York University's postdoctoral program in psychotherapy and psychoanalysis and at the Psychoanalytic Institute of Northern California. She is an editor at *Psychoanalytic Dialogues* and *Studies in Gender and Sexuality*. In 2009, she, Lewis Aron, and Jeremy Safron established the Sandor Ferenczi Center at the New School University. Along with Lewis Aron, Eyal Rozmarin, and Steven Kuchuck, she co-edited the book series Relational Perspectives in Psychoanalysis. She is an editor of the International Psychoanalytical Association's e-journal *Psychoanalysis.today*.

Anton Hart, PhD, FABP, FIPA, is training and supervising analyst and faculty of the William Alanson White Institute. He has presented and consulted nationally and internationally. He supervises at several psychoanalytic institutes and at Adelphi University. He is a member of the editorial boards of *Psychoanalytic Psychology* and *Contemporary Psychoanalysis*. He has published papers and book chapters on a variety of subjects including psychoanalytic safety and mutuality, issues of racial, sexual and other diversities, and psychoanalytic pedagogy. He is a member of Black Psychoanalysts Speak. He teaches at the Manhattan Institute, Mt. Sinai Hospital, the Institute for Contemporary Psychotherapy, the Cleveland Psychoanalytic Center, the National Institute for the Psychotherapies, the New York Psychoanalytic Institute, and the Institute for Relational Psychoanalysis of Philadelphia. He serves as co-chair of the Holmes Commission on Racial Equality in the American Psychoanalytic Association. He is in full-time private practice of psychoanalysis, individual, family and couple therapy, psychotherapy supervision and consultation, and organizational consultation, in New York.

Bandy X. Lee, MD, MDiv, is a forensic psychiatrist who has taught at Yale School of Medicine for seventeen years and Yale Law School for fifteen years. She has consulted globally and nationally on violence prevention and prison reform. She has an extensive publication record, including opinion editorials, peer-reviewed articles and chapters, and seventeen edited books including the *New York Times* bestseller *The Dangerous Case of Donald Trump: 27 Psychiatrists and Mental Health Experts Assess a President* (Macmillan, 2017; 2019). She is also author of the textbook *Violence* (Wiley-Blackwell, 2019) and *Profile of a Nation: Trump's Mind, America's Soul* (World Mental Health Coalition, 2020). She does clinical work in correctional and public-sector settings.

Brent Matheny is an editorial assistant at Oxford University Press in New York City, where he works on books in religious studies, history, and classics. His research interests include the possible social applications for analytic philosophy of language, the philosophy of communication, and revitalizing a feminist ethic of care. He serves as associate editor for *ROOM*.

Bobby Martinez, half Mexican and half Portuguese, is an architect who lives in San Francisco and writes poems when he doesn't feel any alternative. For the last fifteen years, he has enjoyed reading his poetry at Billy and Radical Faerie Gatherings, as well as at the retreats of his sangha. His poems have appeared in *Christopher Street* and in an anthology of contemporary Luso-American literature.

Kyrie Mason is an aspiring writer based in Durham, North Carolina. Currently a graduate student in North Carolina Central University's history program, much of his work, both creatively and professionally, is focused on the relationship between marginalized identities and modernity, particularly where this relationship begins to intersect temporally.

Pamela Nathan is a forensic and clinical psychologist, psychoanalytic psychotherapist, and sociologist. As a forensic psychologist, she worked in mainstream prisons. She is director of CASSE's Aboriginal Australian Relations Program, working on violence and trauma with Aboriginal organizations and people in Central Australia, where she lived in the 1980s and has consulted for over thirty years. She has supervised, researched, developed programs, trained and taught, and published papers and three books as a psychologist and psychotherapist.

Christie Platt, PhD, is a practicing psychoanalyst in Washington, DC, and a practitioner of Zen meditation. She is part of the pro bono network Give an Hour, which provides free counseling services to veterans and their families. In addition, she provides psychological evaluations for asylum seekers through Physicians for Human Rights. She has written numerous papers on subjects ranging from shame in the cross-cultural therapy dyad to mourning the loss of a dog and is delighted to have her first piece in *ROOM*.

Bartosz M. Puk, MD, is a psychoanalyst in private practice in Kraków, Poland. He is a member of the Polish Psychoanalytic Society, the International Psychoanalytical Association, and GroupOne, a group of psychoanalysts organizing clinical discussions along the axis of Oslo-Tel Aviv-Milano-Barcelona-Berlin-Kraków. He is interested in psychoanalytic field theory and art and internet communication, with their adaptation to psychoanalytic work with patients.

Raynell Sangster, LMHC, is a Jamaican-American candidate in the adult program in psychoanalysis at IPTAR. She is also a clinical psychology PhD student at Adelphi University, where her research focuses on identity development among Black girls. Her private practice focuses on providing culturally relevant psychotherapy to Black women.

David Stromberg is a writer, translator, and literary scholar. He is the author of four cartoon collections, including *Baddies* (Melville House, 2009) and two critical studies, *Narrative Faith: Dostoevsky, Camus, and Singer* (U Del Press, 2018) and *Idiot Love and the Elements of Intimacy: Literature, Philosophy, and Psychoanalysis* (Palgrave Macmillan, 2020). He has published a series of personal essays in *Public Seminar* about growing up on the ethnic and cultural margins of Los Angeles, and a long-form essay, "A Nation Wrongs Itself: On American Pain and the Puritan Ethic," on the emotional layers of social uprisings, in the *Los Angeles Review of Books*. His most recent essay, "Grilled Bananafish," (in *Speculative Nonfiction*), deals with pain, abuse, and separating the sources of trauma from the reality we are living.

Betty P. Teng, LMSW, MFA, is a psychoanalyst and trauma therapist who has worked with survivors of sexual assault, political torture, domestic violence, and childhood molestation, both at Mount Sinai Beth Israel's Victims Services Program and the Bellevue Program for Survivors of Torture in Manhattan. As one of the authors of the *New York Times* bestseller, *The Dangerous Case of Donald Trump*, she has written on the trauma of Trump. Betty is cofounder and cohost of the psycho-political podcast *Mind of State*, and she currently sees patients in private practice.

Tuba Tokgoz, native of Istanbul, worked as a psychotherapist in Turkey before relocating to New York. Here, she simultaneously completed IPTAR's adult psychoanalytic training and the clinical psychology doctoral training at the New School. She received a specialization in parent-infant psychotherapy from the Anni Bergman Program and remains active in its Home-Visiting Project, where she treats at-risk mothers and babies using dyadic psychotherapy. She is in private practice in Manhattan and is on faculty at IPTAR's Child and Adult Programs.

Tareq Yaqub, MD, is a fellow in child and adolescent psychiatry at the University of Michigan and a previous fellow of the American Psychoanalytic Association. His clinical work is focused on addressing questions of what it means to be embodied and the psychological impacts of markers of physical "difference." He spends most of his time daydreaming or dancing.

Contents

Hattie Myers
hmyers@analytic-room.com

She often felt herself – struggling against terrific odds to maintain
her courage; to say: "But this is what I see; this is what I see,"
and so to clasp some miserable remnant of her vision to her breast,
which a thousand forces did their best to pluck from her.

— Virginia Woolf, *To the Lighthouse*

Just Sayin'

"Radical openness does not mean that we empty our minds but that we open our minds to the prospect of losing the understandings to which we are attached." So begins **An Interview with Anton Hart**. To be fair, though, perhaps "loosening attachments" when face to face with the trifecta of fascist racism, COVID, and environmental extinction may be near impossible. It's a big ask if, in the midst of existential terror, we are holding on for dear life. The practice of radical openness is marbled with loss. It is an often lonely, sometimes violent, always singular stance. It exists between impossibilities. Two threads run through *ROOM 2.21*: the awareness of what it means to live between impossibilities, and how it feels to live with the violence of being cancelled or rendered nonexistent. Some authors dismantle our perception of time and space; others write of what belonging, or not belonging, has meant to them.

In **Traversing the Liminal: Reflections from Sag Harbor**, Adrienne Harris recaptures the "rupture of 'ongoingness' and the disturbing present of gaps, absences, dissolved spaces." Her reverie crisscrosses through portals opening onto new thresholds of departure. The intimacy Harris establishes with us becomes the answer to her not-so-simple question: "Do history and longstanding connections really hold across shifts in the frame; does the one-on-one contact allow for more links and safety?" Kyrie Mason historically reconfigures the past's "unreal" relationship to the present. In **Things Which Don't Exist**, he tells us, "Admitting to my ghostly blood is to acknowledge the feeling of being fleeting, as if I could simply choose to not exist in a future built on a past which hadn't wanted me to begin with. All this despite the reality of my present, of the frustrations and restrictions and fears I live through daily as a Black American." In **My Eyes Are Brown**, a dreamscape memoir replete with love and clashing traumas, Tarek Yaqub finds a way

to lyrically make a past he never knew his own. Yaqub, a first-generation Palestinian-American psychiatrist writes, "I had etched the family trees of my mother and father into my memory as if I had watered them myself... What a tragedy it is to be exiled from a place you never wanted to leave but never knew."

David Stromberg and Tuba Tokgoz tell a different story of exile. In a **Search for Belonging**, Stromberg describes the psychic toll of being an immigrant Israeli kid suddenly thrust into the belly of east Los Angeles. "I realize my many fantasies were part of an elaborate defense system erected to cope with the constant changes and bombardments of new realities I had to process and in which I had to function in real time." In **Between Two Homes**, Tokgoz describes the "fantastical side of the journey (she's) been on." She writes, "Temporary visas are called 'nonimmigrant visas' which could be why I have difficulty naming myself an 'immigrant,' with its connotations of someone who has made a definite decision about where to live. I prefer the word *expat*, someone who lives abroad and reflects the in-between state of mind that holding a visa entails."

There is nothing "fantastical" in Raynell Sangster's excruciating description of "the many truths Black girls and women live" in her essay **Whose Hair Is It**. "The straightening comb was either seen as a rite of passage or the beginning of a painful relationship with oneself. To straighten one's hair involves using grease and extreme high heat to force the texture of the hair to be pulled straight and to resolve all kink. The sound alone of heated grease reminds me of bacon sizzling on a stove." Sangster asks, "How can Black girls maintain the ability to think about their true self in the face of whiteness?" Paula Coomer is wondering that about white girls too. Coming from a racially mixed and impover-

ished childhood in Appalachia, Coomer wants us to know that "not all of us are ignorant and drug addled, nor are we whites who manage to escape the 'terrors' of the 'hollers' for the hallowed halls of white aristocracy." Her essay, **None of the Above,** is not about living in between (or outside of) two worlds; it is about being both and neither. She wrote, "I regretted it. I knew I was going to be taking up space that needs to be filled with the voices of Americans of color." Like Sangster, Coomer takes her "unruly hair" as a starting point. But, as a white woman writing about her experience, she is well aware that she is stepping into a firing line.

"Wilford Bion said that when two people meet, an emotional storm is created." In his essay **Cytokine Storm,** Bartosz Puk wonders: what happens when two people can't meet in person? A cytokine storm is a hyperactive response of the immune system which is now associated with deaths from COVID. In the context of "radical openness," we might ask what happens when psychic illness triggers an emotional immunity to others and overwhelms our capacity to connect at all. "Witnessing from a distance is not easy," Puk writes. "It's as though one is locked in a spaceship and can do nothing."

In their essays, Christie Platt and Pamela Nathan describe the impact that witnessing up close had on them. In **Motorcycle Man: My First Maga Patient,** Platt looks back over a distance of thirty years to one of her first experiences as a young clinician amazed that "this stranger and I would find each other." She remembers communications "filled with feelings and thoughts so delicate that I felt like I dared not breathe on them, lest he fly away in shame for revealing them." But she also recounts moments of terror when "whatever road we were now traversing felt dark and ominous." In **Whispering Winds: Stories of Pain and Recognition,** Nathan also looks back thirty years to her work as a sociologist at the Central Australian Aboriginal Congress when "it was rare to hear the Aboriginal voice—the aboriginal languages... Historical truth was buried in the Department of Aboriginal Affairs files, and the emotional truth was buried on country with the ancestors; massacred, institutionalized, chained, and criminalized." Now Nathan is a psychoanalyst who works in the heart of the Australian prison system. She too bears witness up close to how "trauma underlies violence" and "nonrecognition and the invisibility of a person and a people causes psychic and communal death."

"Recent events have given us all a 'forced awareness' of our frailty," writes Luca Caldironi in **Quarantine in Venice.** "Perhaps we are forced to examine our relationship with time as it relates to the end of life, and more generally to confront our own fears and suffering." Like Puk, Caldironi calls upon Wilford Bion to strengthen our resolve to enter a space—a labyrinth—of not knowing. What we do need, Caldironi concludes, "is for a few of the experts to be honest and admit to common feelings of fear and uncertainty about what is going on."

Mental health professionals are experts in "not knowing." We know how to follow our patients to places no one has been. We know how to keep our minds radically open to the prospect of losing our own convictions. But this is important: if we lose sight of the expertise that makes it possible for us to, quoting Platt again, "enter dark and sometimes perilous places," then we are really lost. Returning to Virginia Woolf at the top of this editorial, each author in *ROOM 2.21* is saying, "But this is what I see. This is what I see." And yes, Virginia, there are a thousand forces —intrapsychic, interpersonal, cultural, and political— at work to stop them.

It is in this context that Bandy Lee's essay deserves special recognition. Exactly two years ago, in *ROOM 2.19*, Bandy Lee described the death threats, the loss of work, and the public shaming she experienced after the book she edited, *The Dangerous Case of Donald Trump*, was published. Lee returns now to tell us in **Gagged by Goldwater: Speaking up about Trump, Part 2** how the American Psychiatric Association—and the mainstream media in turn—shut out the expert opinion of mental health professionals, and in doing so, she lays out the dire consequences their censorious actions have had. *ROOM*'s editorial group believes this essay is one of the most important essays we have had the privilege to publish in the last four years. It is not about the pathology and danger of Donald Trump. It is about the pathology and danger of mental health organizations or professionals when they are unable to, in the spirit of radical openness, risk losing attachments to their own theories or, worse, to political and economic power.

ROOM 6.21 is now open for submissions. Please join us. We want to see what you see. ∎

Gail Griffin
Gail.griffin@kzoo.edu

2020 VISION

It took opening night and opening day. Took opening.
Took teachers from kids from streets. Your job, your plan.
Took your best friend. Took your first and last breath of spring.
It took your bar, your movies. Your mom. Your man.

We're in it together, it said, then took together. Took you down
and pressed your life out, shot you as you ran and in your bed.
Split your spine right through your kids' eyes. Stalked into town
with a nasty tattoo and an AR-15, locked and loaded.

It spun the Gulf. Seared the West. Took trees old as gods.
Took medics, millennials, mailboxes, voting booths,
and then took Chadwick B. and RBG. Switched out the odds
on logic or love. Worked over the sorry truth

and sold it cheap. Taught your preacher not to pray.
The bastard blew your mind. Took your breath away.

Traversing

Adrienne Harris
adrienneeharris@gmail.com

the Liminal

Reflections from Sag Harbor

The weather report had been dire—a nor'easter, heavy winds, rain. But the day opens sunny and light and warm. I get up from the room in which I have been working for the past ten months and walk into town: Sag Harbor, a village that goes back to the eighteenth century, curving main street, part of the whaling world of the East End of Long Island, now the sweeter part of the Hamptons, a spot for writers and artists back in the '60s, a village with outlying neighborhoods including a middle-class African-American world, the space Colson Whitehead writes about in his novel *Sag Harbor*. I have had a house here for thirty years, so am a relative newcomer, and this past year I have been here more than ever before, moving through seasons, garden blooming and leaves falling, watching through the same set of windows as the light and the seasons change. I am both still and absorbed in a single red room and walking through the village, beaches and gardens, in a natural world that seems eerily benign.

I am walking, doing last-minute shopping for holiday dinners and thinking about writing this essay. I find I want to/need to start with the complicated mix of relief and guilt in which my life is currently being lived. It is in the discourse with many colleagues. Being a therapist, a psychoanalyst, has meant for many colleagues, nationally and internationally, a sturdiness and familiarity to life. My income—and that of most colleagues—has not been affected by the pandemic and attendant crises. I am working a lot, writing and teaching as well as seeing patients. The routines of my work life are unaltered even as the content of sessions change, both following and avoiding the collective experience therapist and patient are having of watching and following the news. Between the composition of this essay and its editing and publication, the political framework has altered in ways beyond imagining. Rooms— the House of Representatives, the Senate, so usually in our minds as representations of work and *gravitas*—are forever altered into frightening signifiers of violence and rebellion.

Virtually everyone I see on Zoom—patient, student, friend, family, stranger—comments on the beautiful color of the room I work in. An odd red-orange East Indian–evoking color, it calms me as well as the other person(s) on the screen. Sitting in another room, quiet and sunny in a house built in 1807, still containing the wide-beamed wood floors, the simple lines of an old house, I read the newspaper, take in the grim statistics. What we see is the COVID-19 social contract and the racism and caste system in which it occurs.

In Chicago, more than 50% of COVID-19 cases and nearly 70% of COVID-19 deaths involve Black individuals, although Blacks make up only 30% of the population. Moreover, these deaths are concentrated mostly in just five neighborhoods on the city's South Side.

In Louisiana, 70.5% of deaths have occurred among Black persons, who represent 32.2% of the state's population. In Michigan, 33% of COVID-19 cases and 40% of deaths have occurred among Black individuals, who represent 14% of the population.

In New York City, this disproportionate burden is validated again in underrepresented minorities, especially Blacks and now Hispanics, who have accounted for 28% and 34% of deaths, respectively (population representation: 22% and 29%, respectively). (Clancy, 2020)

Weekly, I sit in my red study, on Zoom, while my class of young, new clinicians process their first experiences with patients in this daunting time and its alienating spaces. Learning to be therapists on screens and phones, handling unsettling and scary breakdowns and breaks in clinical situations that, even when people and colleagues and teachers are onscreen with them, is so assuredly not the same and not enough. I think of the same experience a year earlier in a live setting where looks, eye contact, smiles, and nonverbal and verbal links create a safe fabric where one can move from novice into more clinical experience. I think back to the capacity, in those real rooms, to support, to stay engaged with fellow students and professor, and to worry. I realized in processing this now that I worry more about the students than about my patients. My patients I feel able to take care of; perhaps there is illusion in this too. Do history and longstanding connections really hold across shifts in the frame? Does the one-on-one contact allow for more links and safety?

I am remembering an amazing talk Joshua Durban gave this past week. On Zoom from Israel, he described harrowing but also very powerful and transformative work with his young and also adolescent and young adult, deeply disturbed patients. Sometimes the screen contained, and sometimes it excluded and fractured, the patients. He spoke about the intense anxieties of his autistic and psychotic patients, people whose earliest experiences or their own subjectivity had been fragile, disrupted, and discontinuous. He was describing disruptions in the earliest stages of linking with a parental figure, lived as bodily anxieties of discontinuity, dissolution, falling forever, freezing and/or burning.

This seemed so familiar to me from thoughts I had been having at the onset of the pandemic, seeing it as an *après-coup*, an event in the present stirring, for all of us, primitive experiences of early helplessness. Durban's patients suffering the more

extreme aspects of these anxieties of being reminded me also of the way Bion and Green describe the early rupture of "ongoingness" and the disturbing present of gaps, absences, dissolved spaces.

For each of us, depending on our early experience of linking and parental attunement, the pandemic evoked and set up the early crises of helplessness and rupture. A patient, whose childhood included the massive disruption of removal from a psychotic parent and unstable time in foster care, began after decades of stability and emotional sturdiness to fear her dissolution and that of one of her children. The universe shook, an experience lived through with varying degrees of disruption and fragility.

Writing about the experience of solitude in the red room, I realize there is another experience in that room when I do not feel alone or alone in a clinical dyad. Early in the experience of lockdown and pandemic, the American Psychoanalytic Association put together process groups assigning each to a facilitator, and I found myself meeting a new group of analysts, spread across the country, different kinds of clinical practices joined on Zoom and joined in a shared (and also distinct) experience of vulnerability. We have met weekly for about ten months. We gave ourselves a name: we were not doing Supervision, we were having CO-vision, as in COVID and cooperative, and we are the CO-visions. I think all of us, in different ways, feel able to say and share things that are hard to say elsewhere, to speak about clinical matters that have often felt unshareable. We send each other readings and notices of talks and projects. We can be light and heavy, frightened *and* aggrieved. I think we all feel blessed.

One final room to speak about: I take the dog for a walk into Oakland Cemetery. I have been noticing how many family plots seem set up as rooms, with entrances, with bushes planted to contour the space where family are buried. The dog and I go to a familiar such room. There is a stone bench, a small tree of a variety I love: stewartia. I read the line on the tombstone where my husband, Bob Sklar, is buried. It's the last line from *The Great Gatsby*, a book he wrote about in his early years as a cultural historian:

"And so we beat on, boats against the current, borne on ceaselessly, into the past."

Now my grandson studies the book in high school. I remember that Bob described it as a book about the West, about coming East, and within that project, it is a story about the illusion that money and youth bring happiness. Right now, at this moment, we are living in and dismantling that dream. ∎

RADICAL Openn

An Interview with Anton Hart

Brent: How does "radical openness" relate to our prior theories about the world, the mind, the particular other, and ourselves?

Anton: The concept of radical openness proposes not that we empty our minds but that we open our minds to the prospect of losing the understandings to which we are attached. In order to engage in a dialogue that could be described as radically open, we bring our prior understandings into the new, emergent conversation with the idea that they, when brought into contact with the speaking and listening of the other person, may be subject to revision, augmentation, or even relinquishment.

If a conversation is pursued with an aspiration toward openness, then there is no "opinion" that exists outside of the relational context. (Well, there might be such an opinion, one that one partner or the other holds tightly to, but that "holding on" would have to be considered as a way of resistively responding to the possible emergent understandings that come from speaking and listening to a particular partner in the here and now.)

Brent Matheny
mathenyb@kenyon.edu

Anton Hart
antonhartphd@gmail.com

Betty Teng
therapybpt@gmail.com

ess

Anton: Perhaps all interpretations are, ideally, best considered as forms of inquiry into the analysand's experience rather than as authoritative statements of the analysand's unconscious truths. And complementarily, all forms of inquiry can be seen to have inherently interpretative aspects. The analyst's choices about which details and themes to follow reflect the analyst's sense of what is important and the analyst's (hopefully tentative and ever-evolving) sense of psychic relevance and truth. In this sense, the making of an interpretation and its mutative reception can be seen as representing an artifact of a change process rather than its cause.

So radical openness proposes not that analysts stop making interpretations but that they hold themselves open to the possibility that the interpretations that they make may have as much, if not more, to say about them as about their patients. As such, the analyst's sense of groundedness, as, in parallel, the analysand's, exists to be potentially, necessarily disturbed in any given analytic dialogic moment.

——————

Anton: I think human beings are all born inherently curious. To be alive means to be interested in reaching out and grabbing ahold of life, through sight, sound, touch, taste, smell, and the thoughts to which our senses give rise. And in the context of relationships, I think that growing up inevitably means that our senses of curiosity are curtailed, due to the fact that one person's curiosity can often be a threat to another person's (defensive) way of maintaining continuity of being and safety from the impingement of the unforeseen. We are all, whether we have been profoundly traumatized or not, perpetually caught between clinging to the familiar and being curious about and open to all that is new, and that which implicitly pushes us toward destabilizing expansion of our senses of the world, others, and self.

Trust must be relationally established rather than presumed. Those who have experienced profound levels of trauma are likely to be less willing than others to be open because allowing others and the world in means risking untold dangers, and they've already had enough direct experience with such dangers, thank you very much.

So we can't start out expecting those who have been profoundly traumatized to be open; more likely we have to expect, at least for an extended beginning of the therapeutic process, for them to be profoundly closed. Accordingly, the place of radical openness in psychoanalytic work with those who have been seriously traumatized is in the analyst's aspiration toward radical openness to the patient's experience, including, most particularly, to the patient's experience of the dangers represented by the analyst themself.

When trying to consider the analysand's sense of unsafety and related defensiveness in a given, present analytic moment, we may emphasize not what others have done to the patient in the past but what forms of unsafety present themselves in the analytic relationship, indeed in the analyst, that could benefit from being taken very seriously—and taken to heart—by the analyst. And I want to emphasize that such radical openness on the analyst's part would take the form, primarily, of the analyst's receptivity rather than some sort of self-disclosure or outward, active line of inquiry.

Brent: Related to my previous question, can we ever be too radically open? Sometimes we might want to say to our interlocutor "you are simply wrong," whether that is about some matter of fact or about a more normative evaluation. Can radical openness advise us in situations like these, where there seems to be fundamental disagreement about reality?

Anton: Radical openness invites us to give serious, cognitively and emotionally open consideration to things that we hear from others that seem strange or foreign, not to replace our sense of self and of reality but to see what becomes of our senses of self and reality when we sit with experience that stands in contrast to one's own. A radically open orientation to dialogue outside of the clinical psychoanalytic setting, such as in conversations across political or other ideological divides, might be possible, but there are caveats...

If a person claims, without evidence, that climate change is a hoax or that the recent presidential election was rife with fraud and was "stolen" (again without evidence and with the existence of pervasive evidence to the contrary), a stance of radical openness is challenged. It wouldn't mean that I take such an interlocutor's claim as valid and probably true in some ways that I can't see. Instead, in order to be open, I'd have to take a step back and think about what goes into the occupying of a position in which the absence of good faith and the disavowal of evidence and reality become permissible or even necessary for the person. Clearly, there is some important information about the person's experience in the world and in relation to me as a dialogic partner, but the truth of it is not to be found in the literal contents of the climate denier's baseless claims.

Anton: I don't think we should relinquish our ethical commitments or our moral sensibilities; I think we can retain these and still aspire to being radically open. I think we can listen to other people who make claims that seem strange to us, or even immoral, unethical or unfactual, and try to consider the poetics of what it feels like as we attempt to take the other's claims into our care. We may feel aversion to what we are hearing; it may seem manipulative, provocative, or even mad. But we may still be able to try to sit with it and imagine what it would be like to say such things, to say such things and to feel and believe them. And in this process of such consideration of foreign notions, including those that pertain to matters of right and wrong, we may gain access to new appreciation of our own understandings of ourselves and the world, and of others too.

Having said this, I do believe that it is likely that some things that one tends to see purely as a matter of right and wrong might turn out to be more complicated than this is if we can bear to consider the complexity, ambiguity, interconnectedness, and unconsciousness of what we each believe. Here is a simple example: I think that it is generally best for people to not interrupt each other when they are trying to have a conversation. I tend to view interrupting as a form of failing to listen, failing to be curious about what the other person is saying, and instead being attached to one's own viewpoint such that it may be deployed as a form of erasing or displacing the viewpoint of the other. So I prefer that my dialogues be civilized in this manner. But what if there are some forms of participating in dialogue that involve talking while the other person is in the midst of speaking, forms that have different assumptions from my own about decorum and appropriate obedience in a given conversation? What if interrupting is, in some respects, a most genuine manner of conveying powerful engagement in what the other is saying? What if the "civilized" idea of dialogue to which I am so attached constitutes, at least in part, a way that the status quo can implicitly be perpetuated, through the way that the conversation is allowed to proceed? There may be elitist or even white supremacist aspect of my adherence to the kind of orderly dialogic process with which I am most comfortable. Radical openness asks us not to abandon our values but to be open to the ways in which our values may contain unconsidered or unconscious attachments or commitments that could, potentially, benefit from being held on to a little less tightly. ■

Christie Platt
christie.platt@gmail.com

Motorcycle **Man**

My First MAGA Patient

Back in 1987, I was in a doctoral psychology program outside of Los Angeles. I had the good fortune to do my final internship in a solidly middle-class section of town at a community mental health center staffed with social workers, psychologists, interns, and a psychiatrist. Every week, we had meetings to discuss new cases as well as chronically troublesome ones. In many instances, the patients who came to the clinic were from the local community and had been coming there for years, as had their families. Such was the case with the man I came to call Motorcycle Man.

When you received a case, you discussed the intake with the entire staff; thus, there were other people who knew about your patients and from whom you could seek advice or additional information. I had learned from the staff that this man's family life had always been turbulent. His mother was severely bipolar and had bouts of psychosis that resulted in ambulances arriving in the middle of the night to cart her off to the hospital while he cried, uncomforted and terrified. Whenever she came home, it was only a matter of time before she would decompensate again. His father was ill-equipped to manage a household with a crazy wife and two children, so he tried to create order in the family by inflicting harsh punishments. Perhaps this came easily to him. He worked for the government managing the feral animal population; this often involved some kind of extermination.

Motorcycle Man was a burly man in his thirties whose muscles exploded from his shirtsleeves and pants. When I first encountered him in the busy waiting room, one knee was shaking so that his boot tapped the floor in an anxious beat. He was one of my first individual psychotherapy cases in an outpatient setting and I, too, was self-conscious as I led him into my little office. I invited him to tell me why he was there. He was a man who I would never have encountered in my ordinary life and I wondered, not for the last time, how this stranger and I would find each other. A little grizzled and very shy, I learned over the following weeks that he was also intelligent and sensitive. He opened up.

I came to call him Motorcycle Man because he told me that riding his motorcycle was the only time he felt powerful and free. At home, he was often cowed by his father's rages. Once, when he was ten years old, his father called him out to the garage and forced him to watch while he beat the disobedient family dog to death with a lead pipe. I am almost certain that he had never spoken about these things to anyone outside his family. He told me these harrowing stories, looking down at the floor, his musclebound body bulging out of the blue Naugahyde chair in the stark consulting room. And yet, our communications were filled with feelings and thoughts so delicate that I felt like I dared not breathe on them, lest he fly away in shame for revealing them.

Like a young child coming home from school with pictures and crafts, Motorcycle Man began to write country-and-western songs, poems, and short stories, which he brought into his sessions. He read them tentatively and with excitement as he discovered this vein of creativity in himself. He even dared to dream that these things might be published one day. He brought me a sand dollar in lieu of the American dollars he could not pay. And he was dedicated, always on time, never missing a session. But none of this resulted in him thinking about what he might do to support himself so that he could move out of his parents' home. Did he even want to move out? If he left, he wouldn't be able to keep watch over his mother. Instead, he created an alternate set

of vocational dreams where his poetic self would be discovered and he would not have to face the fact that he felt useless in ordinary daily life.

One day, he startled me with another one of his dreams: he would start an organization with the acronym VOMP. I almost laughed because the sound of it was comical to me, like an onomatopoetic word to describe some kind of thump. But I could see he was in earnest. "What would that stand for?" I asked. "Victims of Minority Progress," he said with great seriousness. I was taken aback. He imagined creating a movement of disenfranchised white men that would call out the opportunities that had been taken away by minorities, opportunities that rightfully belonged to middle-class white men. Years after I knew him, I heard how many men felt as he did, when factories were moved overseas and decent wages dwindled across the country.

As time went by, he stopped thinking about the ordinary paths to vocational or relational success. He began to investigate the idea of finding a mail-order bride from another country. Somehow, the idea of finding a woman keen to get an American visa seemed more doable than trying to date someone in his own city. Instead, he rode around on his massive motorcycle, stoking his dreams of being a country singer with a sexy blonde bride. He seemed to retreat further and further into the cocoon of his extravagant fantasies.

I felt scared about the direction that his therapy was veering. He was angrier and more grandiose, imagining an alternate world where he was powerful. He continued to blame minorities for taking away the good jobs he might have once obtained easily in a simpler time. By now, I had a private practice and no longer had the wise support of staff who had helped me formulate his case at my placement. I began to secretly wish that he would quit. Whatever road we were now traversing felt dark and ominous. Still, he was invariably two minutes early for every appointment. Until one day, he wasn't. When I did not hear him come into the waiting room, a terrible feeling of dread ran through my body. I waited and waited through the empty fifty-minute hour, fidgeting, mouth dry, worried. Finally, I called his house, and his father answered the phone, "You'll never see my son again," he said, hanging up on me. What could

have happened? What had I done? What had happened to Motorcycle Man and why was his father so angry at me? I was in a state of panic in the days that followed. Four days later, the father called me, "Suppose you tell me what was going on between you and my son."

He had found his son's journals, and while I never learned what he had written, I discerned that I had underestimated the role I had come to play in his life. At last, his father said, "My son is dead. He had a heart attack in his bedroom last week, but I don't want to tell his mother. It will kill her. He is still up in his room. I told his mother that he went up to our cabin and that he won't be home for a while. I need to find a way to get his body out of the house without her seeing it."

He sounded spent, deflated. I said I was sorry and that I had cared very much about his son. Weeks later, he would call to tell me how to visit his son's grave. I went there on a foggy, sad afternoon and found the place where his body and his unrealized dreams rested. There was no one to mourn his death with me, and I felt the loneliness that comes with confidentiality to our patients. Rarely does one have the opportunity to grieve the loss of a patient with others. The intensity of this private relationship cannot be shared with anyone else.

Over the past years, as our country has polarized and so many white men no longer feel secure in their ability to find work, as immigrants and minorities are blamed for taking their jobs away, I find that VOMP keeps echoing in my mind. Motorcycle Man was not alone in his feelings of impotence in the face of a rapidly changing world. He came from a family who lacked the sophistication or psychological resources to deal with his mother's severe psychoses, but whose family does well with that? He was shattered by these episodes which were unique to him but sadly not anomalous. As Tolstoy observed, "Every unhappy family is unhappy in its own way." So it is with the destructive path of mental illness. I came to think of the burly Motorcycle Man as the proverbial canary in the coal mine, snuffed out by the lack of air that he expected to breathe. ∎

2.21.6 **Raynell Sangster**
rsangster24@gmail.com

Whose Hair is it?

Within the Black community, there exists a hidden caste system of "good" and "bad" hair, just like skin color hierarchies. "Good" hair is considered to be closer to straighter, wavier, Eurocentric hair, and "bad" hair is kinkier, coiled, thicker hair. Although these hair valuations are seen as being on a gradient, there is almost always a natural splitting that takes place when seeing and being seen. This dichotomy contributes to the double consciousness in the upbringing of Black girls in America. This twoness originally described by W.E.B. Du Bois is between the "American and the Negro, two warring ideals in one dark body, whose dogged strength alone keeps it from being torn asunder."

I surmise that this internal war starts very young; when a young Black girl is told their hair is too difficult to manage or when they are given dirty looks for wearing their natural hair in public. This pushes many Black girls to hide their hair, hide themselves, in order to avoid those feelings of shame, questionable looks and judgments, and while learning to be accepted if they apply Eurocentric norms. So, is it really our hair when we go to salons to perm (to get semipermanent straighter hair), often causing damage and burns to our scalp? Is it our hair when we install straight hair weaves that pull out our hair, causing bald spots? The validation in these compromised states and being seen so positively is enough to teach us that who we are naturally is unacceptable and we must find a way to fit in and erase a part of ourselves.

School is sometimes the first experience where Black children learn survival skills when it comes to their hair. To quote Ayana Byrd's *Hair Story*, "they are forced to defend it, explain it, and often make excuses for it as white students and teachers remain unaware of their inner turmoil."

Before I dive into what that turmoil may look like and its effects on the psyche, I want to first discuss a familiar story for many Black girls growing up in this society. Many accounts of hair while growing up is one of pain and suffering. The straightening comb was either seen as a rite of passage or the beginning of a painful relationship with oneself. To straighten one's hair involves using grease and extreme high heat to force the texture of the hair to be pulled straight and to resolve all kink. The sound alone of heated grease reminds me of bacon sizzling on a stove. Now think of this sound paired with the sometimes-painful experience of the hot comb burning the back of your neck or making you flinch when it got too close to your ears. This was not something to look forward to but was done to tame the hair to make it more manageable. It was a necessity to look presentable and be more tolerable to others.

The kiddie relaxer often marketed as the pain-free option to the hot comb came into fashion because it permanently (with the exception of chopping off all your hair) changed the texture of your hair to be straighter hair, unaffected by moisture. The perm would happen whenever there was "new growth." That is, whenever your natural hair started to grow out again and show, it was time for the perm to cover it back up. The pains of relaxing one's hair is very known and has its own set of messages. Sometimes it is seen by parents as a convenience because of a busy work schedule, which sometimes says, *I don't have time for you.* There are also physical consequences of the perm: bald spots, burns, severe hair damage, especially when not treated properly. There is a constant need to tame herself to be accepted by America's visual norms without causing a disturbance. What a trauma to recognize the Black self.

As a child, I was acutely aware of how my hair appeared to others. When doing something as innocuous as going into the pool, I would feel the sense of relief because I knew having a perm would "protect" me from being seen in my natural state. There is a process of knowing and trying to unknow. How can Black girls maintain the ability to think about their true self in the face of whiteness?

Black girls and women live many truths. The painful truth of existing in this world and of knowing what it takes to live in this world. We are in a world where laws must be passed to not discriminate against Black hair. The Crown Act was created in 2019 to protect against discrimination based on race-based hairstyles such as braids, locs, twists, and knots. Its purpose is to create a safe and open environment for people to wear their natural hair. To think, we as a society need laws in place to safeguard those whose hair is not like the "majority." Although this addresses a larger issue of discrimination in schools and the workplace, it doesn't do justice to the psychological impairments that are experienced as a Black person growing up in America. The implications they absorb include: I am too difficult; people will like me more if I make drastic, painful changes to myself; people don't have space for me; I must assimilate more than others to be valued; my feelings are lesser than yours; I have to change myself to fit in or I have to change myself to not be noticed; and why am I on display, must I always be conscious of my appearance and how it makes others feel?

I will end with another quote from Ayana Byrd's *Hair Story* which says, "I hate the way our hair can speak so many words for us before we open our mouths." ∎

Pamela Nathan
pamela1nathan@gmail.com

Whispering Winds

Stories of Pain and Recognition

*Japanangka was born in the old time amongst his ancestors, an Anmatjirra man, and found wandering
nomadically over the red earth in a world of timelessness on sugar ant country, making country camps
all over the land with the old jilpas under the stars, and steeped in bush lore from centuries ago.
Fat kangaroo and bush turkey were in abundance and the country was green and grassy under the swaying
she-oaks. Still, Japanangka stood tall, astride a horse, stockman's gait and strong. He had an akubra hat glued
to his head, a cheeky smile, dancing eyes, rolling laugh, and light brown skin. He was the son of a Nordic man
and tribal woman and had to blacken his wide face for the welfare boys and run and hide far away from camp,
playing with his shanghai until the white fella mob were gone. When the devil mob came with their cattle
and destroyed his sugar ant lands, he went droving the cattle as far north as Camowheel and got paid with flour,
trous', and tobacco. He became the head stockman, boss man and bucked on wild, kicking horses bareback,
and had to leave his country for long stretches of time. He lived among the white fellas far from his country
and kin for sun-ups and downs of time; his homesick heart ached in concert with the whistling winds and rose
and fell with the crackling embers of the fire, night after night, and he sent smoke signals along the tracks
to his country, on the back of the whispering winds.*

In the early 1980s, the heyday of Land Rights, I lived in Central Australia, working as a sociologist with the Central Australian Aboriginal Congress. A senior Aboriginal man, Dick Lechleitner Japanangka, worked alongside me, and we visited many Aboriginal communities and coauthored two books: *Health Business* and *Settle Down Country*. We held many meetings and recorded in language—on film and in print— the voices of Aboriginal people. We fought for two-way medicine delivery and for the Pintupi people returning to their lands to be provided with essential services. Some recognition for the dispossessed was achieved by hearing and reporting their stories and by advocating Aboriginal determination. In those days, it was rare to hear the Aboriginal voice—the aboriginal languages translated directly into English in the public and policy arena. Historical truth was buried in the Department of Aboriginal Affairs files, and the emotional truth was buried on country with the ancestors; massacred, institutionalized, chained, and criminalized. Aboriginal people, however, recognized their losses, at dawn and dusk, lighting their wailing fires in ancestral memory. Recognition led to new developments such as the Alukura—a place where young women could give birth by the Grandmother's law and the Pintupi people were able to leave settlement life, return and settle, with Dreaming, Law and Ceremony at Walanguru, which is now a thriving community. The voices of Aboriginal people challenged colonial hegemony in the hospitals and the courts and clamored for recognition.

The center was life-changing! The seeds of recognition were planted! I returned from the desert to the city and trained in psychology. Fresh out from university, graduating with a master's in psychology, I was then plunged into the deep end, getting my first job in G division at HMG Pentridge Prison. At the university, I counseled a woman with a driving phobia. At Pentridge, I counseled a man doing time for axing his pedophilic predator to death. High-profile criminals were my clients—murderers, rapists, pedophiles, and more. Were they human? How could I work with them? On the first day, I was taken on a tour of the prison by the prison guards, and I gagged outside the walls—they had taken me with great relish to D division and shown me the gallows on which Ronald Ryan was put to death, the last man hanged in Australia in 1967, the wet cells, the cabinets of confiscated weapons, and more. How could I work there?

A year later, I can say I learned a lot and my quest began, the quest to understand what happened to these people to make them psychopathic killers. Each time I went through the turnstiles, I thought: *Here I go by the grace of God.* I helped them find their voices and tell their stories, and I listened to them. They all had a story. They all became human. I told their stories to the parole board and to the courts. They were no longer nameless "crims" or file numbers, but mostly, they were very damaged human beings whose damage became palpable as the stories unfolded—sexually abused, beaten, neglected, latchkey kids, with broken families, alcoholic or absent fathers—you name it. Tyranny, imprisonment, and damage were writ large on the files, but not in visible ink—it had to be gleaned, deciphered, discovered, and made bold.

Their violence was driven by fear. I learned to stop them when they were in an aggressive tirade— stop them dead in their tracks––by telling them that I felt afraid and wondered if they were scared also, and that's why they were acting like standover men. I asked them, "When have you been stood over and afraid?" Without fail, their stories would unfold. Invariably, they experienced relief and gained understanding into what had made them commit beastly acts. For many, no one had been by their side to hear, hold, and name their pain. Few had been seen or known or recognized as human beings who suffered and had suffered. The prison walls are filled with unrecognized trauma marked by silent screams, bleeding wounds, restricted psychic development, and the primal cries that ricocheted the cell walls: "Mummy, Mummy, where are you?" I learned that we can all live inside prison walls, imprisoned, frightened, blinded, ignorant, and most of all, nameless.

Thirty years on, I took the long and arduous lessons learned about recognition to the red center to work again with Aboriginal people. I had completed psychoanalytic psychotherapy training. Now, I knew that we can all inhabit dry, dusty desert lands in the mind with parching thirst and hunger pains. Trauma, I knew, sears like molten metal. Alice Springs was recently privileged with being called the stabbing capital of the world. Through the Gap which is at the entrance to town, the dingoes howl in fright, jolting the caterpillars of the MacDonnell Ranges and ripping the silence of the desert like lightning strikes. The traumatic shield has been breached. Aboriginal people have been stood over by the violent colonialists and had their fear anesthetized by alcohol and disfigured into a lateral violence. Aboriginal people speak a different language, and their deep generational sorrow remains unknown and invisible, save for the shrieking violence doused in alcohol. I know we all know the language of the suffering heart.

The white fellas and the cattle multiplied across his country like bushflies, and he became a boss man for his people, learning to talk to the white fellas who were like the perishing bullocks, no good, but destroying their country, the fat of the land. His strong voice boomed "get off our land" and the white fellas cowered, froze like the frightened roo and slunk off like the dingo dog until the fires died down. They made empty promises and created more bloody carcasses, letting the flies buzz around, the black crows circle and swoop the kill, and the fires blaze in the red blood, burning the country. The white fellas had loaded their guns to get rid of the Black fella pests off their land, those who stole cattle and their kin were shot at Coniston.

Psychoanalysis helped me work with the inmates and Aboriginal people, helping me to find their humanity, their voice, their feelings, and their stories (and my own). Psychoanalysis helps me understand that trauma underlies violence and that nonrecognition and the invisibility of a person and a people cause psychic and communal death. Psychoanalysis can be very practical and can provide tools for living and self-actualization, possibilities, and freedom. Most of all, psychoanalysis provides the recognition of emotional worlds, and recognition provides a means to know and see and to be known and to be seen, and the telling of stories, the sharing of pain with another, can transform emotional experiences and create new stories and renewed lives. ∎

Japanangka became a guardian for this place and could often be seen sitting on the bench outside the old welfare office, Kwemenje's office, his akubra slung low, chewing a match in the corner of his mouth, smoking a rollie cigarette, drinking a billy of tea, sitting, sometimes so still, never missing a trick though, with his dancing brown eyes, which could spot a kangaroo in dense shrub miles away without even a turn of the head. Sometimes a hooting yukai could be heard across the yard and the erstwhile silent, still Japanangka could be seen doubling over in laughter, and the whole yard would shake in unison and smother the ever-present lone mopoke cry.

Smoke

When we bury
 smoldering fires of desire,
 the body fills with dense smoke

and every vow we make
 steeps in ashes. Wrap
 your regrets in the tight skin

of supple leaves, so no light
 or air filters in. Walk to a river,
 release them into the steady

current—watch as they drift
 then disappear into the world
 without you.

2.21.9
Kyrie Mason
kyriemasn@gmail.com

Things Which Exist

**I've become fascinated with the undead,
with impossible things,
things which don't really exist.**

Another fixation of mine has been the impossibility of my ancestors, particularly the abducted and the enslaved. Through the wound which would be called the Atlantic Slave Trade, Black persons were simultaneously the subject, the object, and the labor. Put another way, Black persons were the commodity—something akin to a gold piece, the means of production—which we would now call *human* capital, though such a qualifier is missing in enslavement and, ironically, in the subject. In the case of Black persons, the traits of subjectivity—communication, relationship, organization, aspiration, *ad infinitum*—were forcibly recognized either in their negative (as in the forbiddance of some otherwise common human practice) or in their grotesque affirmation (such as with the concession of small pleasures or the mechanic exploitation of human impulses). In this way, the Black person is canceled out in a triple negative, an impossibly impossible subject, further complicated by their intercession with other unreal things.

Reasoning in this way, I trace my lineage back to phantoms—persons who existed as unreal in their time, dying only to transition to a state of detached undeath. Thus, I claim my identity as a ghost and become another impossible subject. And while the sensation of my impossibility is something which my body—fingers to stomach to toes—had intuited, my mind had only seen it on the periphery. It may be something like Du Bois's famous "double consciousness" or the invisibility of Ralph Ellison's iconic antihero. Admitting to my ghostly blood is to acknowledge the feeling of being fleeting, as if I could simply choose to not exist in a future built on a past which hadn't wanted me to begin with. All this despite the reality of my present, of the frustrations and restrictions and fears I live through daily as a Black American.

What are those things which don't exist?

This first came to me when thinking about, as historian Mae Ngai formulates, the impossibility of illegal immigrants: a person which, existing and participating within a given society, is not only excluded from the legal representation but in fact is expressly forbidden by the law of that society, an "impossible subject," something which exists in unreality.

Or consider the canceled futures of Mark Fisher, the subjects of his hauntologies and retro-fixations. In the ahistoricity of the twenty-first century, we are trapped

in repetitive obsessions with the stillborn futures of past decades. These futures were once hopefully speculative, born from moments of possibility, but now unachievable in the nightmarish inertia of late capitalism—still they persist in our cultural imaginations, our fixation giving them a stunted relevancy without life as we feed from their carcasses, gnawing from their psychic scraps in an attempt to nourish our enfeebled creativity. Another impossible subject, something which exists in unreality.

One of the tragic jokes of the day is the collective obsession with storytelling, ancestral veneration, and "decolonization" within communal discourse. Not that these things in themselves are valueless, but that in many ways they are cyclical. The collective obsession with the past is as much a symptom in Black America as in white America; haunting is an American neurosis. It is an ideological phenomenon, of which we were all birthed and caught in; there is no escape or reckoning with these ghosts. The gag of reclaiming Yoruban religion or Griot traditions or West African heritage foods by Black Americans is that many of us are as foreign to those things in our current modalities as any other *westerner*; we learn about them on an intellectual level, and there is little

retention in the body, but still it's all only resemblance, resemblance far removed from context and grown out of an absurdist, purgatorial condition. Can Black Americans still be cultural imperialists? Certainly, the answer is in half of our demonym. Even in the wake of the recent past, with the advent of intersectionality, hip-hop, afrofuturism, and the like, more and more I feel myself perplexed by the questions of Hortense Spillers in *The Idea of Black Culture:* ultimately, what will we be when there is no longer white to react against?

These observations may ring as trite moral judgements, but I am in the exact same position, equally trapped, continuously frustrated though longing to be hopeful. Yet I wonder, if the Americas were to die, and its ideological children along with it, what would happen to me? Not myself as I am now, but my being as it lives through remembrance. Can I be an ancestor in a post-revolutionary world?

Or perhaps, when I die, I'll be just as all the other ghosts are now, kept alive by my impossibility, remaining and never passing on or passing away—lingering as something which exists in unreality. ▪

Gagged by

Speaking Up about Trump, Part II

1. Lee, B.X. "Speaking Up about Trump, An Experience of a Lifetime," *ROOM: A sketchbook for Analytic Action, 2.19* (February 2019)

Bandy X. Lee
bandy.lee@yale.edu

Goldwater

As I write this at the turn of the year, hospitals are overflowing, and our medical system is about to collapse. Yet the approaching loss of a half million lives in the United States from COVID-19 was entirely preventable. For me, the disastrous mismanagement of the pandemic was always more a mental health issue—of the head of state. So is the reckless discrediting of a normal election, the violence in the streets that have now flowed into the Capitol, and the near destruction of our democracy. This was all foreseen by mental health experts and may have been prevented had the discussion about the president's dangerous psychology not been quashed by a single mental health organization: the American Psychiatric Association (APA).

Having spent most of my career as a specialist in violence prevention applying psychiatric principles to public health, I could see the vast psychological influence Trump would have on society. I was deeply concerned that silencing experts would enable the spread of mental pathology alongside an inability on the part of government to apply correct interventions, both of which would ultimately result in immense suffering and societal damage.

An alarming event in March 2017 prompted me to act: the APA's revival of the obscure Goldwater rule, a guideline that prohibited the psychiatric diagnosis of a public figure without personal examination and consent. The APA expanded this "rule" to prohibit psychiatrists from publicly commenting on any objective aspect of a public figure and stipulated no emergency exception. In other words, the APA turned this antiquated guideline into a gag order that superseded all our primary professional responsibilities. Using the Goldwater rule to privilege a powerful public figure above an entire society's right to have the best available knowledge to protect itself seemed to me the first sign of authoritarianism.

So, I assembled other prominent mental health professionals, first to an ethics conference at Yale School of Medicine and then through the bestselling public-service book *The Dangerous Case of Donald Trump: 27 Psychiatrists and Mental Health Experts Assess a President.* More than fifty members of the U.S. Congress eventually met with us. They said: "If you continue to do your part and educate the public on medical matters, we will be able to do our part and act politically." By January 2018, we had raised the matter of the president's mental health to the number-one topic of national conversation.

2. BillMoyers.com Team. "Bill Moyers talks with Dr. Bandy Lee about *The Dangerous Case of Donald Trump*," *Moyers on Democracy* podcast (January 14, 2021)

3. Lewis, T. "The 'Shared Psychosis' of Donald Trump and His Loyalists," *Scientific American* (January 11, 2021)

4. Lee, B.X, et al. *The Dangerous Case of Donald Trump: 27 Psychiatrists and Mental Health Experts Assess a President* (Thomas Dunne Books, 2019)

5. American Psychiatric Association. "APA Calls for End to 'Armchair' Psychiatry," APA Press Release (January 9, 2018) Retrieved from https://www.psychiatry.org/newsroom/news-releases/apa-calls-for-end-to-armchair-psychiatry

6. Lieberman, J.A. "Psychiatrists Diagnosing the President—Moral Imperative or Ethical Violation?" *The New England Journal of Medicine*, Letter to Editor (February 1, 2018)

7. "Is Mr. Trump Nuts?" *New York Times*, Editorial. (January 10, 2018)

8. Lieberman, J.A. "Maybe Trump is not mentally ill. Maybe he's just a jerk," *New York Times* (January 12, 2018)

9. C-span. "The Dangerous Case of Donald Trump," C-Span.org. Lee, B.X. et al. Video and transcript (March 19, 2019) Retrieved from https://www.c-span.org/video/?458919-1/the-dangerous-case-donald-trump

10. World Mental Health Coalition "Authors of *The Dangerous Case of Donald Trump* Release Mental Health Analysis of Mueller Report," WMHC Press Release (April 25, 2019)

11. Lee, B.X., Fisher, E.B., Glass, L.L., Merikangas, J.R., Gilligan, J. "Mental Health Analysis of the Special Counsel's Report on the Investigation into Russian Interference in the 2016 Presidential Election." World Mental Health Coalition (April 25, 2019). Retrieved from https://worldmhc.org/mueller_report/

Then the APA intervened. They made a public statement denouncing our work as "unethical" and moved to discredit our efforts.

In a damning letter to the editor in the *New England Journal of Medicine*, past president of the APA Dr. Jeffrey A Lieberman wrote, "Psychiatry has made too many past missteps to engage in political partisanship disguised as patriotism…I believe that Pouncey and Lee and her coauthors are acting in good faith and are convinced they are fulfilling a moral obligation. But I believe this is a misguided and dangerous morality." The *New York Times* joined in by publishing an editorial chastising psychiatrists who would speak up, as well as a lengthy op-ed penned by Lieberman.

It did not seem to matter that all the core tenets of medical ethics pointed to our professional obligation to protect public health, above and beyond any etiquette we owed a public figure. A widespread and ongoing misinformation campaign had launched to discourage the media from giving voice to mental health experts.

For example, when our growing group of concerned mental health professionals—now called World Mental Health Coalition (WMHC)—invited more than fifty news organizations to a large interdisciplinary conference on the president's overall fitness for his job, more than half of them declined to report on the event, citing the Goldwater rule.

We watched the media comply with the APA suppression by routinely supplanting mental health experts with political pundits. The resulting fog of misinterpretation seemed as destructive as the gutting of institutions, the replacement of career personnel with unqualified flatterers, the catering to a president's emotional needs at the expense of public good, and ultimately, the use of presidential powers solely for the expansion of personal power. Without expert input to explain the abnormal behavior of public figures, the dangers we had anticipated were minimized and pathology was normalized, inducing a "malignant normality."

Despite the obstacles, we continued to perform our professional duty. When Special Counsel Robert Mueller released the findings of his investigation, we did our own analysis. Mueller's report may not have been enough to indict a president, but it gave us the perfect information for a mental capacity, or "fitness," evaluation: abundant, high-quality reports from coworkers and close associates under sworn testimony, which are valued over a personal interview. Top mental health experts from around the country formed an independent panel, then by standardized assessment, we concluded that Donald Trump did not meet any of the criteria for fitness. In fact, lacking even the most basic mental capacity for rational decision-making, he was unfit for any job, let alone president. We offered the president a chance to interview with us—to demonstrate his fitness—but he did not respond. Therefore, we published our conclusions with recommendations that: (a) the president's access to the nuclear codes be removed and (b) his war-making powers be curtailed. But without means to garner significant public attention, our message was largely ignored.

Then, in late September 2019, everything changed. A whistleblower revealed that the president had allegedly abused his powers and the governmental purse to help his own reelection campaign. This led to the Speaker of the House finally announcing an impeachment inquiry.

12. Pramuk, J. "Whistleblower complaint is out: It alleges Trump abused power to influence 2020 election," CNBC.com (September 26, 2019)

The WMHC had long encouraged impeachment, but for it to proceed nearly three years into the president's incessantly scandalous term—a protracted window that allowed him to swell maximally in his false sense of omnipotence and impunity—was potentially dangerous. Our knowledge of human psychopathology provided us a blueprint for understanding and anticipating the actions that would most incite potentially aggressive and violent responses out of Trump. We were concerned that without guardrails, Trump's psychology suggested he would retaliate, possibly invoking presidential martial powers. So, we released new public statements and submitted letters to Congress warning them of the dire implications of the president's impairment and recommending psychological containment strategies before it was too late.

In early October 2019, Drs. Stephen Soldz and Edwin Fisher and I, along with more than two hundred fifty mental health professionals, sent an urgent letter to Congress. Three days later, Donald Trump ordered the withdrawal of troops from northern Syria, causing the massacre of our Kurdish allies.

13. Croucher, S. "Trump Is a 'Successful Sociopath' and a Predator Who 'Lacks a Conscience and Lacks Empathy,' Says Former Harvard Psychiatrist," *Newsweek* (October 29, 2019)

In early December 2019, Drs. John Zinner and Jerrold Post and I, this time along with over eight hundred mental health professionals, sent another warning. A month later, Trump ordered the assassination of a top Iranian general, Qassim Soleimani, to the surprise of even military officials, bringing us to the brink of war with Iran.

14. Porter, T. "350 health professionals sign letter to Congress claiming Trump's mental health is deteriorating dangerously amid impeachment proceedings," *Business Insider* (December, 5 2019)

WMHC then issued our most urgent warning, but the House proceeded with its vote and handed over the articles to the Senate. As a result, the House's impeachment efforts only enraged the president, and when the Senate acquitted him in a sham trial, his destructive impulses went uncontained, enabling his triumphal State of the Union address and his vengeful firing spree of those who lawfully testified against him.

Our final warning to Congress was delivered less than two weeks before the first United States case of COVID-19 in January 2020. Suddenly, the danger we were warning against turned into an unprecedented domestic threat. Not only had Donald Trump, out of pathological envy of his predecessor, defunded the Centers for Disease Control and Prevention (CDC) and dismantled the pandemic response teams that had been lauded throughout the world, he had also fired the CDC's team in China, whose job was to detect and contain the very kind of respiratory infectious disease we faced with COVID-19. With a deadly pandemic arising just when the president most believed himself immune to prosecution, the number of infections and deaths in the United States quickly surpassed China's and then every other country on the planet.

Had the House of Representatives held on to the articles of impeachment a month longer, removal may have been more likely, as more of Trump's malfeasance came to light. Instead, the now-acquitted, apparently invin-

cible president jubilantly declared the pandemic another "hoax" by the Democrats. He psychologically recruited his base into his alternative reality and resisted necessary actions such as widespread testing and tracing as well as isolating and mask-wearing—our only recourses. The result was that the U.S.—in spite of all its wealth, resources, concentration of experts, and military might, and much to the surprise and pity of the entire world—became the global epicenter of the pandemic. And there was no going back. A central pathology of Donald Trump is that he can neither admit an error nor take responsibility for his actions. Instead, he turned defiance of public health measures into a fight for freedom.

In early February 2020, I issued statements that control of "the mental health pandemic" was vital for effective control of the viral pandemic. In late March 2020, the World Mental Health Coalition issued a "Prescription for Survival," stating that the president's removal, or at least removal of influence, was critical to containing the U.S. death toll. We issued "Refills" or "Urgent Updates" in August, November, and December 2020, when eighty-five million Americans were planning to travel over the holidays, despite the raging pandemic that was claiming three thousand lives per day. At the time of this writing, one in one thousand Americans are already dead—five times the global average—and the death toll is projected to be a half million by the end of February 2021.

Just as WMHC predicted earlier consequences for not instituting containment of the president's psychology, we anticipated this lethal mishandling of the pandemic, exactly as it would happen, before it happened. I published a "blow-by-blow account" of our predictions and efforts to raise the alarm in August 2020. Further, our mental capacity evaluation assessed that almost all final deaths from COVID-19 would be attributable to the president's mental state—and not the characteristics of the virus—which has been confirmed by a large Columbia University study.

Our work has never stopped: over the summer, we also published *Our Documents*, containing over three hundred pages of our letters, petitions, and conference transcripts. In October, I published a guide for healing the country, *Profile of a Nation: Trump's Mind, America's Soul*, a complete psychological analysis of Donald Trump in the context of his followers and the nation, in which I anticipated the post-election turmoil. We held a town hall series, which included an emergency reunion of speakers from our major interdisciplinary conference, along with special guests John Dean and Dr. Noam Chomsky. In late September 2020, more than one hundred senior mental health professionals went on video record to declare Donald Trump too psychologically dangerous and mentally unfit for the presidency or candidacy for reelection. Finally, after the election, to explain the psychological upheavals we expected, I started my short, daily videos, *A Psychological Take on the News*.

All those who accidentally came across our material would tell us they could not fathom how we were not a greater part of the national conversation. Mental health professionals could have brought the knowledge necessary for

15. World Mental Health Coalition "Prescription for Survival: Emergency Update," WMHC Statement (December 21, 2020) Retrieved from https://worldmhc.org/prescription-for-survival/

16. Lee, B.X. "The Trump Mental Health Pandemic," *Medium* (August 14, 2020)

17. Redlener, I, Sachs, J.D., Hansen, S., Hupert, N. "130,000-210,000 Avoidable COVID-19 Deaths —and Counting—in the U.S." National Center for Disaster Preparedness, Earth Institute, Columbia University (October 21, 2020)

18. World Mental Health Coalition. *The World Mental Health Coalition Documents* (World Mental Health Coalition, Inc. 2020)

19. Lee, B.X. *Profile of a Nation: Trump's Mind, America's Soul* (World Mental Health Coalition, Inc. 2020)

20. World Mental Health Coalition. Emergency Interdisciplinary Conference "Donald Trump's Great Harm to America and the World," WMHC Statement, (October 2020) Retrieved from https://worldmhc.org/emergency-interdisciplinary-conference/

21. World Mental Health Coalition. "100 Senior Psychiatrists and Mental Health Professionals Sign Statement Declaring: The Extremely Dangerous Case of Donald Trump." WMHC Statement, September-October 2020. Retrieved from https://worldmhc.org/100-senior-psychiatrists/

politicians to act when the public was still on board. One of the greatest travesties, I believe, has been the silencing of relevant expertise. The people are empowered for self-government only when they have access to knowledge. Experts, in turn, have an obligation to society that far exceeds a mere technical role. One would have thought a mental health association such as the American Psychiatric Association would help and not harm a nation's health, but they were too busy getting on the new, lucrative bandwagon where mental impairment is the same as mental health, criminality the same as good intentions, and corruption and exploitation the same as political success.

Still, they cannot subvert the truth. No amount of distortion and deception can change the fact that human life is precious, and our care for that life paramount. In other words, no special interest is worthier than the nurturance of human health and the safeguarding of human survival. This was the reason the World Medical Association instituted the Declaration of Geneva in 1948. This universal pledge for all health professionals—established in response to the experience of physician collusion under Nazism—emphasizes that we speak up in contexts of injustice and especially not collude with destructive governments. The APA may have won for now, but humanity endures, and history will have its verdict. ∎

22. Gersen, J.S. "How Anti-Trump Psychiatrists are Mobilizing Behind the Twenty-fifth Amendment," *The New Yorker* (October 16, 2017)

23. Fingar, C. "The silencing of psychiatry: is the Goldwater rule doing more harm than good ahead of the US 2020 election?" *New Statesman* (September 22, 2020)

24. Kendall, J. "Muzzled by Psychiatry in a Time of Crisis," *Mad in America* (April 25, 2020)

25. World Medical Association. "WMA Declaration of Geneva," WMA statement, original September 1948. Retrieved from https://www.wma.net/policies-post/wma-declaration-of-geneva/

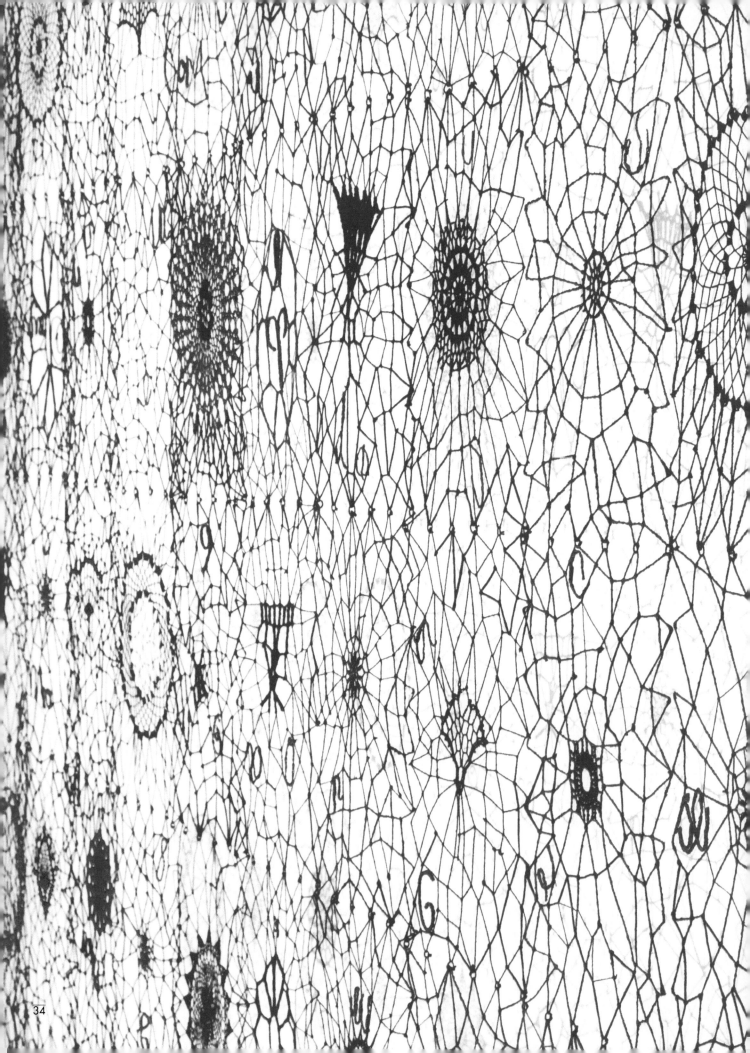

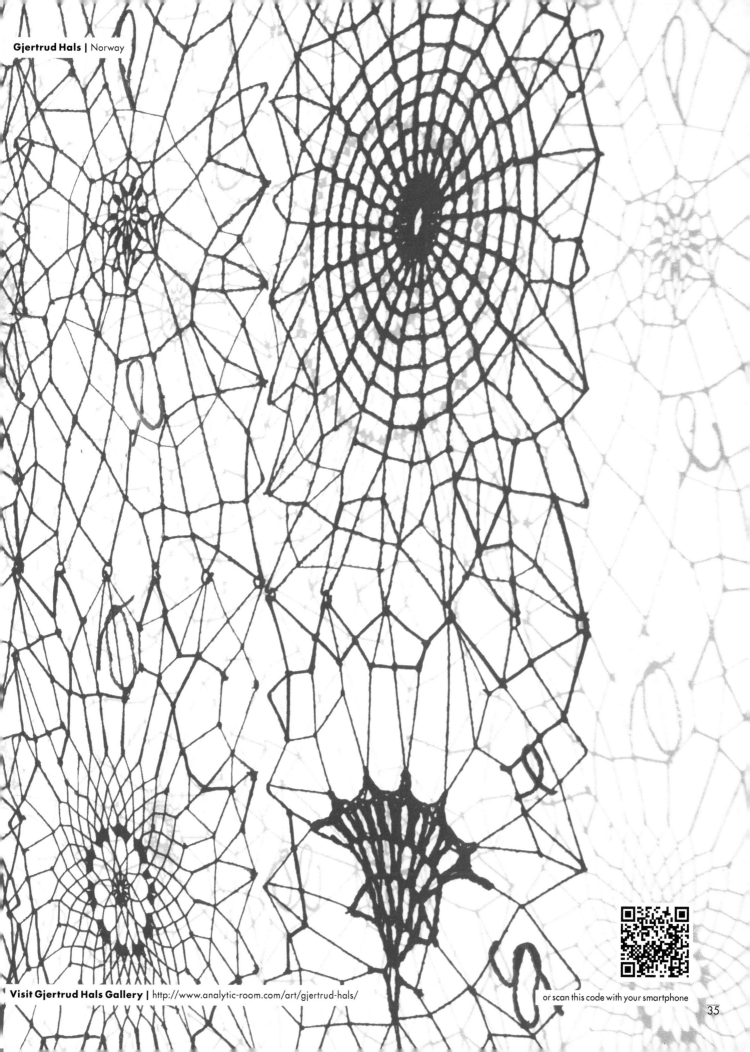

David Stromberg
davidashdodi@gmail.com

A Search for

Growing up in America with immigrant parents, you're often on your own navigating your future, and so institutions like elementary school become more than just places of study. They become agents of social advancement. One day, in fifth grade, someone came to class and told us about magnet schools, explaining that you could apply to study a particular subject at a particular school. Getting into the program was connected to the category you'd been assigned in tests you'd taken, and there was a mysterious point system that helped you get into this or that school.

I was put into the "gifted and talented" category and, taking the little booklet they gave us, read over all the different options for middle school. I decided I wanted to attend the 32nd Street School / University of Southern California Visual and Performing Arts Magnet and to become an actor. I got accepted, and I was sure that my move to America was connected with some greater fate. I needed to believe that all these difficulties were being endured for *something*. In reality, this was just the first in a series of desperate dashes to find a place within American society where I could feel not only safe but also that I was able to realize some of the gifts and talents that the Los Angeles Unified School District identified me as possessing. The sad fact is that I'd succeeded in merely getting myself out of one difficult reality into another. Because, as an immigrant kid with little context, I was guided mainly by a headful of fantasies, delusions of grandeur, and a hefty dose of ignorance.

Today, when I can reflect, I realize my many fantasies were part of an elaborate defense system erected to cope with the constant changes and bombardments of new realities I had to process and in which I had to function *in real time*. I developed some convictions that became deeply entrenched and that influenced the course of the rest of my life—some of which took decades to break down, and others that still influence my sense of self today.

The main thing I felt—I remember walking down Sunset Boulevard on the way to school, looking up at the blue sky, and thinking it—was that, for some unknown reason, God had taken me out of my land, but that, when the time was right and I'd learned what I'd needed to learn during my exile, I'd be called back home.

The motivation for such a conviction is obvious: it gave purpose to what would otherwise have been an unbearable separation from my mother as well as the country in which I'd been born and where I'd grown up. At the age of eight and a half, I had only lived in America for six months, so my existential identity was rooted firmly in Israel. That life was not, in itself, peachy. We lived in a working-class port town until I was almost six, and my dad made his living creating Judaica statuettes for tourists and selling them in a small corner gallery in Old Jaffa. When I was seven and eight, I lived with my paternal grandparents and mother in a small two-bedroom apartment in an immigrant part of Jaffa. My mother taught organ at a music store in Tel Aviv, while my grandfather managed the B'nai B'rith event hall. My distress in America was not caused by a fall from grace. On the contrary, despite our hardships, life in America had provided a measure of stability simply because we were no longer living under the constant threat of war. But I could not, as a child, accept that this was going to be my home forever. I was in America to survive. I would know when the time came to go back.

The problem was that the relative stability that life in the United States seemed to offer in comparison with Israel was belied by the instability I saw built into American society. This materialized, first and foremost, in social instability. For one, I never once saw a doctor as a child. My dad had a cardiol-

Belonging

ogist friend he'd known growing up in the Soviet Union, and when we needed a health certificate signed, we'd drive over to the doctor's giant house in the Pacific Palisades to get his signature. As for my teeth, between the ages of nine and thirteen, I didn't go to the dentist once, which left me with eight cavities and, eventually, a mouthful of amalgam silver fillings. It's not that my father didn't *want* to take me to a doctor or a dentist. It's that we didn't have insurance and couldn't afford to spend money just so that a doctor would look at me and say I was healthy. That, for an immigrant family, is a major waste of money. You go to the doctor when something's *wrong,* not to make sure that everything's *all right.*

But there was a deeper instability—immigration. I saw around me people who were struggling and suffering to make ends meet, supporting families as day laborers, newspaper deliverers, gardeners, and housekeepers. Their kids, with whom I went to school, faced pressures that ranged from gang violence to learning difficulties to a basic lack of English. Some of their parents spoke even less English than they did and depended on their children to help them navigate their own daily lives, including dealing with everything from paying bills to caring for their younger siblings. I at least had a Black American stepmom at home to teach me the ways of the world and the rules of the street.

I was no longer afraid of being attacked by a neighboring country, but I was terrified of walking down the street. I can still see the memorial candles and bouquets of flowers covering the corner of Vendome and Marathon Streets, left after the death of yet another gang member. I can still hear police helicopters flying over our house, the spotlight filling my room in the middle of the night. I can still feel the fear of riding down Sunset Boulevard on my skateboard, hounded by a kid on a bike who came up to me, pulled up his shirt to show a

screwdriver tucked into his pants, and told me to give him my Georgetown Hoyas cap. I said no and ran into the tire shop on the corner where the owner let me call my dad and wait for him to pick me up in his car. We lived a block away.

The violence in the neighborhoods where I grew up was different from what I'd experienced in Israel, and at least for me, it was in many ways scarier. This had mostly to do, I think, with the fact that I was just so different from the other kids. Not that they were homogeneous among themselves; there were kids from Mexico, El Salvador, Guatemala, and a few from Asian countries like Korea, Vietnam, and Sri Lanka. But each of these groups were tied to a community in which people spoke their language, commiserated over their difficulties, and experienced a sense of belonging that counterbalanced the difficulties of their daily lives.

I observed these kids and their communities with envy. Our family history was not connected to anything anyone around me had ever experienced. We'd had too specific and narrow a trajectory to connect to any community of our own: the Russian-speaking Jews who'd come from the Soviet Union knew little of Israel, the Israeli Jews who'd moved to America had no idea about Russian Jews, and the American Jews who'd grown up supporting both Soviet Jewry and Israel ultimately knew very little about either. And, ultimately, my dad was an individualist who'd come to America to escape the confines of communal life and to build for himself a future that suited his needs and interests. There was no place better than Los Angeles to offer precisely the opportunities he sought.

I did not seek this kind of life. Not because I wasn't an individualist but because I also yearned for a sense of belonging. And belonging was not a commodity I found readily available in the America where I grew up. ∎

Between Two

2.21.13 **Tuba Tokgoz**
 tubatokgoz@gmail.com

Homes

Just before arriving in New York as a graduate student, I was consumed by Harry Potter novels, which describe a boy seizing his chance at a life in an alternate universe with its own realities and its own customs and history. What is valued in the old world is not necessarily appreciated in the new world, and vice versa. Novels such as *The Hobbit*, *His Dark Materials*, *Chronicles of Narnia*, and *Coraline*, in which characters travel to imaginary worlds where time and reality flow differently, resonate with me, perhaps because moving to another country involves bold changes in every aspect of life—geography, climate, architecture, customs, language, and even time. As one's body functions for a while according to the previous time zone's clock, the physical and emotional jet lag become a powerful reminder of the sharp differences between two existences. Heroes in fantasy novels face the challenge of their worlds being turned upside down but also the promise of finding parts of themselves that could not be realized in their old worlds. I suspect that the exciting and scary promise of transformation lay beneath my wish to move to New York. I also suspect that this search for unrealized parts of oneself, a desire for internal exploration, inspires the curiosity in internal processes needed to become an analyst[1].

Although my life is mainly in New York, I remain connected to my birthplace, Istanbul, where I return regularly. No matter where I am physically, my childhood home there still appears in my dreams—it is within the depths of my being. It feels fantastical sometimes to fly to Istanbul; in just ten hours I'm on a different continent, in a different city, speaking a different language, and connecting with people as if I had never left. Perhaps I want to think of this commute as a wondrous journey, another world I can dip into to escape from the deeper, more painful sense that each journey, with its ensuing

[1] Hanna Segal observes that Spillius identified through a survey that "the majority of analysts are people who have been 'displaced' in some ways—it's as though they were in search of a home somewhere."

separation from loved ones in two worlds, is a reminder of the inevitability of endings, the limits of our beings and our lives, and ultimately death.

I tend to attribute the distress in leaving Istanbul to my separation difficulties—my difficulty letting go of my childhood and the people I am attached to from that earlier time. Perhaps due to an analyst's inclination to focus inward, I tend to forget that these feelings also could be connected to my precarious status as a visa holder. Internationals who hold a green card, which provides permanent residency and promises citizenship, are more secure than internationals who hold a visa, which allows only a temporary stay. Visa holders have limited access to services, have no voting rights, and are required to renew their visa every few years. Temporary visas are called "nonimmigrant visas," which could be why I have difficulty naming myself an "immigrant," with its connotations of someone who has made a definite decision about where to live. I prefer the word *expat*, someone who lives abroad and reflects the in-between state of mind that holding a visa entails.

Visa holders have always lived with uncertainty, knowing they may have to leave the country when the visa ends, but during the Trump administration, this immigration category has come to experience an arbitrariness that makes it nearly impossible to feel safe even within a granted visa period. The Trump administration has applied new prohibitions against various foreigners under visas. In July 2020, after strong criticism, the administration decided not to ban international student visas, but since elected, Trump has targeted and banned most types of work visas (H-1B, H-2B, L-1, J-1) as well as green cards issued outside the United States. Then the pandemic became a justification for increasingly aggressive and restrictive policies, which created further angst among many internationals.

Presidents' attitudes and policies on immigration have varied throughout U.S. history. However, postures became drastically less welcoming after the attacks on September 11, 2001, which occurred just two weeks after I arrived in New York. Trump's portrayal of immigrants and immigration as dangerous and harmful and his efforts to limit immigration have generated enormous hostility toward immigrants and internationals. Yet Bush and Obama, however different in their immigration rhetoric and philosophies, shared a similar stance toward immigration post–September 11; in fact, Obama deported more immigrants than Bush and Trump. Although Trump took extreme measures to restrict immigration, his attitude was a continuation of post–September 11 fear of "the other."

Sadly, I have been witnessing this fear since I came to New York—not so much in my daily life and relationships, but definitely in the bureaucratic sphere. During Obama's administration, my student visa changed to a work visa, granted only upon my proving that I contribute to the field of psychoanalysis. The renewal of this visa during the Trump administration involved an excruciating process of scrutiny and tragicomic hurdles where I had to provide evidence that I already proved sufficiently that I had met the criteria for the visa. It is impossible for a visa holder not to get the bureaucratic message that one is not welcome, similar to the messages in Trump's attempted bans. This bureaucratic reality contrasts starkly with my daily lived experience of being at home in New York, a city that constantly moves me with its radical acceptance of the other. Is it possible to ignore one's experience of the bureaucracy[2] and have a life in the new land no matter what? International visa holders face this split on a daily basis.

Studies on asylum seekers show that individuals with insecure (temporary) visa status have higher levels of psychological distress, including depression, suicidal intent, and trauma symptoms than those with secure (permanent) visas. Individuals with temporary visas also display more difficulties in their post-migration life than those with permanent status. Studies also show that conversion of one's visa status from temporary to permanent leads to a major improvement in mental health. Although we cannot generalize about all internationals from studies of asylum seekers, they nonetheless communicate the vulnerability of temporary visa holders, namely that living with extended insecurity about one's immigration status has a detrimental impact on psychological health. Parallel to the challenging external adjustments that internationals go through, there are internal adaptations

[2] I'm accustomed to the stressful process of visa application, as most countries require a travel visa from Turkey. A visit to a European country, for instance, requires multiple proofs of income and accommodation, bank statements, letters from employers, travel insurance, application forms and fees, etc. These documents are required even if the person will only make a flight transfer in a European airport. The time, energy, and money spent to get a visa even for a flight transfer is huge, and again, the bureaucratic message is clear. I have Turkish friends who refuse to travel due to this agonizing process, as they experience this treatment as humiliating and discriminatory.

to inevitable psychological losses. Visa uncertainty adds to these stressors and creates an even more pronounced feeling of being in limbo.

What has always helped me with my insecure visa status has been the security of relationships, which have provided a sense of safety that has helped me to ignore not having permanent status. The study I cited above has a similar finding: social engagement was found to be a protecting factor against depression for individuals with temporary visas. Psychoanalysis and psychotherapy could be considered a remedy for internationals who are in a state of lingering insecurity.

Separation is a crucial emotional task that we continue to rework internally throughout life. For international visa holders, separation becomes burdened by the external and bureaucratic realities of immigration. Perhaps as a way to cope with this harsh reality, I turned my focus inward and tended to see the fantastical side of the journey I've been on. As Minh-ha beautifully puts it, "Love, hatred, attraction, repulsion, suspension: all are music... The more displacements one has gone through, the more music one can listen to." Despite the uncertainties of displacement, the process of discovery inescapably expands one's internal limits and opens one to sounds not heard before. ■

References:

• Al Sharafat, A. "Attitudes of the United States' Presidents Towards Immigration," *RSA Journal* (2019)

• Minh-ha, T. T. *Elsewhere, Within Here* (Taylor and Francis, 2010)

• Nickerson, A., *et al.* "The association between visa insecurity and mental health, disability and social engagement in refugees living in Australia." *European Journal of Psychotraumatology* (2019)

• Quinodoz, J. M. *Listening to Hanna Segal* (Taylor and Francis, 2008)

• Waddell, M. *Inside Lives* (Karnac Books, 2002)

My Eyes Are Still Brown

I look up from the dinner table and find my grandfather's gray eyes. I wonder if they have always served as colorless emblems of his passivity. My grandfather is visiting, which means we are having fish for dinner...again. I am growing frustrated by the monotony. I ask if he ever grows tired of seafood. He laughs nervously in a way that somehow induces a sense of guilt within me. He begins to speak slowly. He struggles to find words. His narration begins to intertwine our consumption of fish with the many transpositions of the map of Palestine. It starts to make sense.

He recalls a past in which his father, who was infamous for his insatiable appetite, would gluttonously finish all the available seafood in a restaurant in one sitting. My grandfather seems both embarrassed by and proud of this retelling. I wonder if the colorlessness in his eyes is the outcome of this persistent state of mixed emotions. He is conflicted by identifying with a father whom he both loved and resented. As he is speaking, he pauses with more frequency than usual, as if he is reflecting on what his legacy will be. After a particularly long pause, he begins to speak with more vigor. He begins to lament the quality of market fish in Palestine ever since Israel seized control of all borders. Now more animated, he mourns his painfully disrupted romance with the Mediterranean at the hands of the Occupation. He relays his feelings of frustration with being de facto landlocked. He tells me that eating fish with me is a temporary escape from that reality. In this moment, I see a tinge of blue, of life, in his eyes, as if they are capturing the moment in which the waves of the Mediterranean Sea begin to crash...

Crash... C-section. The monitors are ringing, and by the looks on the faces of the doctor and nurses, things are not going as anticipated. The fluorescent lights are blinding, somehow both amplifying and drowning out the confusion.

My mother has been in labor for nearly one day. How inconsiderate, she must think, for the baby to come early but then refuse to leave. My mother's heartbeat is racing; mine is doing the opposite; we've never really seen eye to eye. Now, however, my mother and the obstetrician are in disagreement. She's trying to piece together what he's saying: "fetal decelerations...nuchal cord...crash C-section."

Three weeks earlier, my mother had boarded a plane and crossed the Atlantic to safely deliver me, her first son and child. My father was to follow her shortly after; however, given work and visa complications, he was left trapped thousands of miles away, separated again by borders and an ocean.

I am swimming in my own private ocean, tethered to my mother via an umbilical cord. Water betrays us again, and somehow the cord is wrapped around my neck. My heart rate begins to fall. This, of course, means that my mother must have her abdominal muscles ripped open to save her precious first son. The obstetrician's words are becoming louder and more rapid: "We need to perform a C-section emergently."

My mother, who has never been one to acquiesce to the demands of any man, refuses. She crossed an ocean alone for this moment, and no man— physician or a fetus— is going to dictate the terms. She wants to deliver the child "naturally."

"Your baby is going to die," the physician says slowly but angrily.

"No, he won't," my mother says with a confidence and optimism that could have only been born out the experience of being occupied and displaced twice, but somehow still committing to a belief in a better future.

The physician is becoming increasingly frustrated and, now, nervous. Fearing a negative outcome, the physician presents my mother with a waiver stating she is declining the C-section. My mother apprehensively, yet confidently, signs it. This is my signal. Amid the screams of my mother, my head decides to finally make an appearance. I am welcomed into the world with a blue body and noose around my neck. My mother declares her victory over "modern" medicine. Within minutes, she is holding me in her arms, and our brown eyes meet for the first time.

Thirty years later, I am on the phone with my mother, advising her to be vaccinated against the flu during a pandemic. It's all coming full circle. The first man I ever met was a physician telling my mother what she should do with her body, and here I am now, a physician advising my mother on what she should do with her body. I'm thinking of the times I've demanded access to and tried to have power over my mother's body. When I was cold, I was swaddled inside her shirt; when I was hungry, I reached for her breast; when she was pregnant with my sister, I repeatedly asked about the expansion of her stomach, often touching it. My sister occupied my home of nine months, and I wondered if she, too, would be thrust into the world violently. Would she also be betrayed by the body that slowly strangled me and spit me out after nine months of feigned hospitality. Would she, too, be exiled from a place she never wanted to leave, but no longer remembers?

I can no longer tell if I am speaking about my mother's body or of Palestine. I only know that I am no stranger to exile. Perhaps I avoided leaving my mother's body and nearly hung myself in the womb when I knew I would not be born in Palestine. Two and a half decades later, I finally found myself on Palestinian soil, in my homeland, my motherland. My whole life had prepared me for this moment. I had etched the family trees of my mother and father into my memory as if I had watered them myself. I marched in protests nationally. I occupied state-owned buildings and supported B.D.S. (Boycott, Divestment, Sanctions) resolutions. I repeated the stories of my grandfathers: their rendezvous on the seas, their teaching positions, their mercantile stores. I waited through the humiliation of being interrogated by Israeli soldiers with their guns pointing at my face, right between my eyes.

Throughout my childhood, I had envisioned this moment: an Israeli Defense Forces soldier welcoming me home with a gun to my face. In my childhood fantasies, I always found a way to humiliate him for threatening me. In none of those fantasies did I freeze. In none of those fantasies did I stop speaking Arabic, switch to English, and show him my American passport to prove that my life was somehow more worthy than the lives of others. In none of those fantasies did a docile version of myself show my return flight to Michigan as a sign that I had no claim to the land I was visiting. In none of those fantasies did I feel absolutely nothing when the romanticized return to my grandfather's home finally occurred. In none of those fantasies did I separate myself from being Palestinian in order to step foot into Palestine. In none of those fantasies was there an absence of feeling whole upon returning "home."

What a tragedy it is to be exiled from a place you never wanted to leave but never knew. Thirty years later, I am still searching for a place to call home, and I think to myself, in those moments interfacing between the womb and the world, was I fighting to live or fighting to die? I think that maybe I should have invited the soldier's bullet into my flesh. Perhaps that would be the proper way to fill the void left by exile and its humiliation. I wonder what my grandfather would think about that. I don't want my eyes to be gray like his. ▪

None of the Above

I am in the not-unique position of coming from mixed heritage. Like many of us who hail from the Kentucky and Tennessee Appalachians (we pronounce it *apple-ate-cha,* not *apple-atsha*), my family is a mix of African, Native, and Scottish. Except for the white boy who raped my fifteen-year-old Cree/Cherokee grandmother to make my mother. We don't really know what he was, other than the obvious. In old photos of my family, we look like a checkerboard. The young ones are towheaded and fair-skinned, the grandparents wonderfully burnished, the between generation coffee and cream. My father was the oddball, with bright red hair and pale blue eyes, whereas my mother resembled her mother, with black hair, oaky skin, and deep, dark eyes.

This mix played itself out by bestowing on me unmanageable, bushy, strawberry-blond hair. The moment I took my first job at the young age of fourteen, I began going to salons where they regularly put relaxer on kinky hair. The salons that catered to Black women, in other words. I loved those places and those women. They looked at me knowingly and smiled. Not one other person looked at me in such a way—judgingly, yes; knowingly, no. Mostly people at school made fun of me. Not because of my hair but because of my plumpness. *Lard ass* and *sweat hog* are two names I remember most.

I wonder where those boys are now.

My locks do not look like that today. "The bush," as boyfriends and husbands called it, mostly fell out during my second divorce and grew back quite differently. Wavy, smooth enough that a little gel takes care of the kink. My last relaxer was in 1992. Bittersweet, you could say: a sad gift to my more aware adult self, a relief to my teenage self who was schooled by catalogs and magazines to think that a smooth coif was essential to a happy life. All those years of Dippity-do gel and sleeping on orange juice cans and ironing my hair on the ironing board every morning—you people who grew up with flattening irons and curling rods have no idea how lucky you are—and trying every means possible to make it look "normal." Of course, I never could have articulated that I was trying to look "more white." All anyone has to do is to glance at my exterior to know that I have lived my entire life with white privilege. Although I would argue that white privilege wanes when it is hillbilly white privilege; we suffer our own brand of harmful and inaccurate media depictions and cultural prejudice.

Why did no one tell me it was okay to walk around with a headful of bushy strawberry-blond hair? Because race was not once mentioned in my family. EVER. NOT ONCE. I remember one summer when I was perhaps sixteen, quietly asking my two grandmothers why they were so tanned. That's the way I saw them, as very tanned. They told me it had to do with working outside in the garden. I pondered the fact that they remained equally tanned in winter, but never posed that question. I did not know who we were and where we came from until I was nearing forty. After I became a writer, I began doing the research and asking the other questions I'd always considered: Why does Grandpa C. have brown skin and thickish lips? Why did he go to prison and Grandpa S. didn't? Why does Uncle J. look like a Black man? Why does Grandma look like an Indian? Why does—? Why does—?

"It was so long ago it doesn't matter," my father said, and refused to discuss the subject further. I was kicked to the family

curb for asking these questions and because of my nonevangelical, feminist perspective ("too much education for her own good"), and for reporting a little thing about my mother's white stepfather having molested us girls during our towhead years. In truth, my mother's white stepbrother threatened to kill me if I ever showed up on the family homestead again.

We are finally enabling the voice of "the other" in our country, though a day late and a dollar short, as the saying goes. I see America as an adolescent moving through the trials that will hopefully lead to her adulthood. Still, I've been told in no uncertain terms by my Black and Native friends that no matter my background, I've been afforded white privilege, so, despite my intense discomfort and internal discord, I can't really talk about these feelings in terms of my race. I can argue that I've mostly been poor, that I've been held back and abused by white male supremacy, that I've been invisible because I have been overweight and at times obese, but none of these things matter because no police officer has ever pulled me over for being fat, and I know this. I am not woke, as people are calling it; I'm simply experienced enough to get it. I know what my nonwhite family members suffered because of the color of their skin. My mother was stared at on buses and downtown streets in our Midwest town so often that by the time I was fourteen, she began refusing to go out of the house. My father's brother with his amber skin and wide nose and kinky black hair he laid flat with pomade was beaten nearly to death trying to cross a picket line in order to feed his family, yet white scabs weren't. My maternal grandmother's story was echoed when Mom, at sixteen, was raped by her white stepfather. Whether she bore and gave away his child has been argued both directions.

Black/white, either/or. Good/evil. I don't mean to minimize the difficult issues before us or to sound insensitive. I'm not insensitive. I feel my African great-grandmother. I feel my Cree/Cherokee great-grandparents. I feel my Scottish ancestors, who were marginalized, despised people on this soil too. I have also felt every police murder—in my cells, in my corpuscles, my DNA. I have felt them until I could not breathe or move or speak. The deep parts of my genetics have experienced this exact violence and more, much more. I myself have been beaten by my mother with a tree limb until my back and legs were a mat of welts—more than once.

My relationship to what happened in this country in 2020 is magnified by the fact that my own son is a police officer. He's wise, generous, and feels his responsibilities perhaps too deeply. He's capable of crying over what he's seen on the job and is a bit of an Andy Griffith–style father to his children, including my willful, red-haired, wild-locked granddaughter. He went into the job because he knew he could do it and do it with dignity, and because he wanted to serve humanity.

I've wept, too, over the people who came recently to his area and who wanted to kill him and other police officers in our isolated region. White men with guns—the same ilk who just stormed the capital—traveled to his rural university town to face off with a police department that has never had an officer-involved shooting. Most of the job of officers in our cluster of tiny towns is corralling drunk college kids; talking down domestic disputes, would-be suicides, tweakers high on meth; and gathering the picked-clean bones of people who die alone with their beloved pets.

What a horror this was for our more or less innocent populous. All at the hands of white, right-wing Christian males with military-grade firearms who think their way is The Way. Their eyes are the eyes of adolescents: their insular point of view translates to *my way my way my way mine mine mine mine*. Connected to a local evangelical church, these men came in response to the city council decision to enforce a mask mandate. I sat vigil for days, waiting to get the call that the worst had happened. I should add that this same group drove our number of COVID cases to the heavens during the summer and have continued to do so—dozens of our local people died because of them. They accomplished murder without firing a shot.

The stark differences in our perceptions of reality in this current time knock me off balance. We Americans might as well be looking at the world through individual kaleidoscopes. I suspect this is a mode of faulty coping, much the way my mother's lashing out with the tree branch was. Perhaps my son, the police officer, said it best, when we spoke after the melee was

over. Pointing to his family dining table, he said, "Here's what I want to tell those people. Look at this table. It's made of wood, correct? You can spend your time and energy focused close in, marveling over the finish, obsessing over the intricate, fine grain of the wood, over the original tree's meaningful representation of the passage of time, of seasons of rain and drought, at nature's artistry in the knots, in the movement and variations in the swirls, or you can take a step back and realize that what you are actually looking at is a table, where people of all kinds can join together to share in what we all need: community and a meal."

Not long after I submitted this piece for publication, I regretted it. I knew I was going to be taking up space that needs to be filled with the voices of Americans of color. In light of subsequent conversations with writing colleagues from across the Appalachian region, I decided, however, to allow publication in hopes of bringing another perspective and to help counter the hurtful stereotype of the hillbilly, which is in a way, also based on race, I believe, considering our mixed nature, and which again has been put in front of U.S. viewers in the form of the film version of *Hillbilly Elegy*. The publishing and film industry has only one mindset when it comes to producing works out of Appalachia. I want them to hear this: not all of us are ignorant and drug-addled, nor are we whites who manage to escape the "terrors" of the "hollers" for the hallowed halls of white aristocracy.

Some of us are neither. ∎

Luca Caldironi
luca.caldironi@gmail.com

"Out of darkness and formlessness something evolves."
—W. Bion

The title of the last Venice Biennale Art exhibition was "May You Live in Interesting Times," and the title of the next Architectural Biennale exhibition is "How Will We Live Together?" I found these two topics not only extremely interesting and provocative but also particularly pertinent to the reality we are experiencing right now. Let's start with the first. What times are we living now?

We are experiencing what I would call a "forced awareness" of our frailty. We are "forced" by events to "force" our psychic mechanisms to defend us from approaching calamities that make us aware of our vulnerability, to examine our relationship with time as it relates to the end of life, and more generally to confront our own fears and suffering.

Very often, despite having achieved enormous successes in enhancing the quality of life, even medicine and psychiatry have not helped us keep our eyes on the murkier aspects of our collective psyches. Because of our lack of awareness or our lack of psychological tools, we willingly and quickly settle when guided by stimuli and advice from authority figures, or just trusted friends and family, hoping to comfort us with siren songs like "don't think," "distract yourself," "think of something else," etc.

But when an "other" arrives instead, we find ourselves going from a situation where we always felt omnipotent, where anything seemed possible, and where we could challenge every limit, to a situation where we suddenly find ourselves on the ground (or on a sofa at home in this case, if we are lucky!). In any case, it was not a very soft fall, not only because of the health emergency, which of course is the primary concern at the moment, but also for all the subsequent social and economic complications that have arisen and will continue to in the future.

We feel as if we woke up lost, the GPS of our life crushed. On one hand, this is a discovery of the obvious; it is experiencing a concept dear to Eastern thought known as "impermanence." The irruption of the Real arises as a strong presence in contrast to the Virtual. There is a "catastrophe," an "overturning" of the scene, thus the common description, "Everything is upside-down right now."

As in Greek theater, this experience is a crucial hub of and in the tragedy itself. Because we are experiencing this Overturning on several levels, we must move from external spaces to an internal one. The interpersonal safety margins must be wider, more expanded. We must live the paradox of feeling close when facing the problem together, while physically staying apart to protect ourselves and others.

Turning now to the title of the next 2020 Architecture Biennale: "How Will We Live Together?" This title has become extremely provocative, not only because this biennale has already been postponed and we don't know if it will open but because of the interlocution and challenge its title poses for us, right now and for our future.

Once again, we are faced with the paradox I mentioned earlier, a paradox that involves our global and globalized life in which contact or touch will increasingly need to take place tactfully and with sensitivity, and with all the attention and care of our heightened sense of responsibility.

Developing a citizenship that cuts through the individual, the community, and the environment can represent a challenge to making us feel like we're part of something bigger than ourselves. That does not mean stepping aside but rather doing our part. Can the play of words "shared distance" be the space in which we will now live together? And how can such a major shift in thinking and action be implemented? There will be many such *hows* in our collective future, and each time, it will be up to us to deal with them wisely in that moment.

We are living the paradox of simultaneously needing mutual social assistance and being required to distance ourselves from each other. A sense of greater social responsibility has been born in all of us from this catastrophe, which is not and cannot be only individual, and though we are necessarily apart, it is a collective experience.

Forced isolation or coexistence in the same space has several definitions—these include the relationship everyone has with themselves (self-talk), the condition of their mental space, and the unique internal struggles they are experiencing.

I think of our minds as labyrinths we all must enter and from which we inevitably emerge transformed. In the labyrinth,

we will encounter horrors, the fears we are able to ignore in the bright world outside, but that find us in times of fear or heightened anxiety. In ancient mythology, these fears took the form of monsters such as the minotaur. Since the journey into the labyrinth is psychological, not actual, the minotaur is of course symbolic. That is, it represents something else within our own psyches. In today's world, it might be this virus we're all hiding from, or the monstrum, as the Latins called it. The monster can take many forms.

In the labyrinth, we may also have an encounter with ourselves. Can that moment become one in which fear does not become panic, anxiety does not become anguish, worry does not become depression, and restrictions do not become persecutory experiences?

When experiencing a feeling of impotence because of a formidable enemy, whether visible or invisible, man has always developed some form of collective aggregation to ensure his survival. But we also know that these forms themselves can be affected by destructive phenomena. It is a very delicate balance.

If COVID-19 is a phenomenon of the globalized world, I believe that the globalized world is also the resource for fighting its "dark side." In this sense, the COVID-19 virus can then represent the "negative" (in the sense of old film cameras), which can help us understand what is going on. In a wider sense, it can also help us understand globalization itself and develop a more noble component of or from it.

Might all humanity use the immense power of our imaginations to illuminate a myopic, anthropocentric point of view and give more space to creativity as a way of "listening" —to rethink not only globalization but the idea of nature, both of which humanity is completely, intricately, and unavoidably a part of.

We must enter our own labyrinths to face this pain and try to handle it in the more three-dimensional and deeper space of suffering. In ancient Greece, there was a saying: *To pathei mathos*—wisdom is achieved through suffering. In other words, transformation can only take place when the pain is felt, not denied.

Even the word *suffering* and the verb *to suffer* take us back to an internal space. The word *suffering*, which is closer in meaning to the ancient Greek word *pathos*, but is derived from the Latin *suf-ferre*, meaning "to put or take something inside," with the consequent implication of a passage from a superficial dimension to a deeper emotional space.

All this refers us to an ontological problem, one of life or death. In the broadest respect, it is the relationship that each of us has with our own finitude. This thought sounds depressive on the surface, but it is anything but, because it goes to the core of everything that makes life a unique opportunity for joy and creativity, and it takes us to a place where all our feelings and emotions can converge.

Bion wrote, "The incapacity to build a mental space that tolerates ignorance or uncertainty induces the creation of a language of action, from where power can be exercised arbitrarily... The capacity of the mind depends on the capacity of the unconscious-negative capability. Inability to tolerate empty space limits the amount of space available."

But why talk about all this?

Perhaps precisely because we are realizing that despite the cacophony of expert voices, no one really has all the right answers or can predict the future with certainty. And perhaps we are also a little tired of behavioral decalogues that look more like "presumed knowledge" to us, and what we really need is for a few of the experts to be honest and admit to common feelings of fear and uncertainty about what is going on, so that we can feel less alone in our fear. ∎

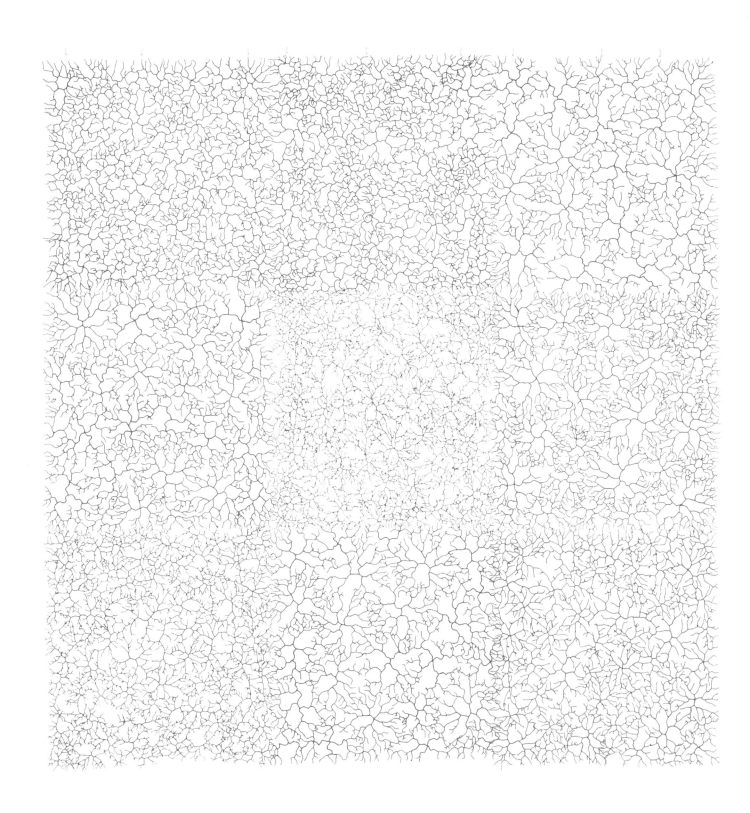

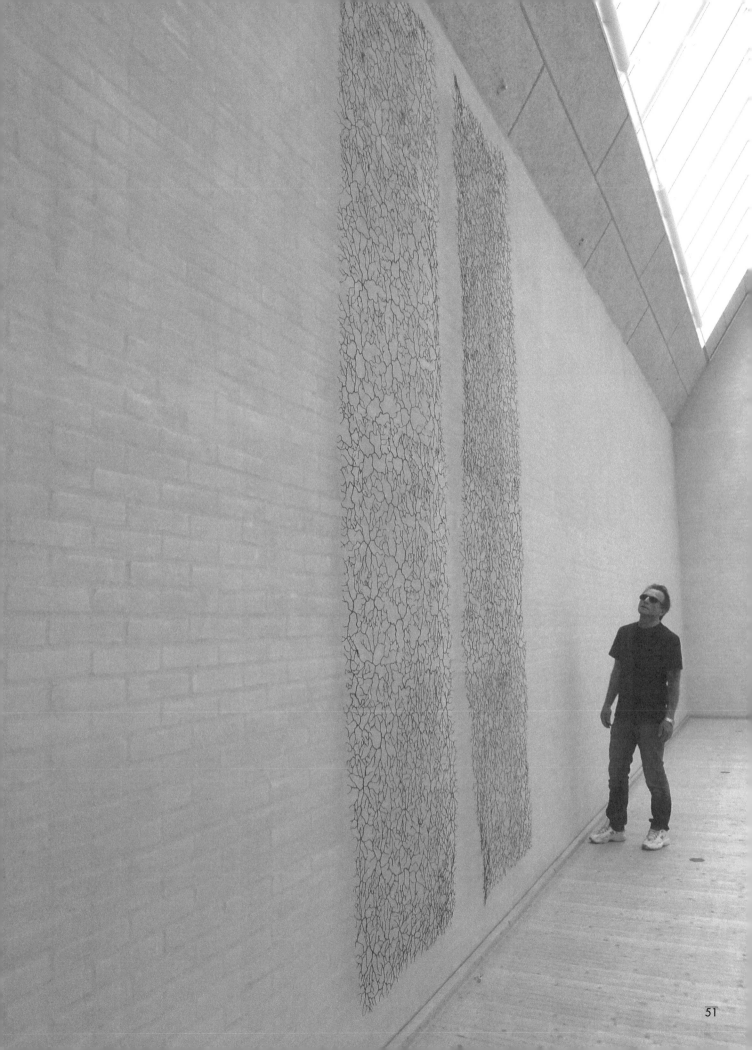

Bartosz Puk
bpuk@icloud.com

Cytokine Storm

Bion said that when two people meet, an emotional storm is created. What are the possible cytokine-emotional storms when two people cannot meet? Can they be felt in mutuality still without an individual breakdown?

This so-called "cytokine storm" has been occupying my mind throughout the pandemic. On hearing of people dying within two weeks of a confirmed COVID-19 infection, I felt terrible. A lot of my patients and friends have lost someone close in these personal storms. And all we could do was keep a safe distance and watch what was happening to them as the storms on earth consumed them.

Witnessing from a distance is not easy. It's as though one is locked in a spaceship and can do nothing.

Others are down there, are physically closer, but they are locked in their tanks on the battlefield.

Perhaps it is an anecdote I heard or dreamt of that Wilfred Bion was with a team in a tank caught in enemy fire, and all they could do was wait, hoping the onslaught would not destroy the tank walls and that relief would eventually come.

One of the soldiers could not stand it, and he opened the hatch and started shooting his pistol in the enemy machine guns' direction. He dropped back into the tank dead, a massive bullet hole in his head. Bion said that was the moment he realized what it meant "to lose one's head." The soldier, as Bion thought of it, had lost his head before opening the hatch.

So, I try not to lose my head, help to do the same for my patients, and also try not to float away from earth's storming reality.

These cytokine storms of so many COVID-19 patients and these tank-encapsulated states of mind have caused emotional storms in the psychoanalytic spaces I find myself in with my patients.

For fifty minutes, we could float in space, but every time there was distant thunder, we felt it inside too.

There was George, my analysand, whose sessions are at 10 a.m. In the wider world, the Polish Ministry of Health chose 10:20 a.m. as the time each day when they would tweet out the number of newly infected cases and the number of new deaths. So, when 10:20 came, George and I would interrupt our work to check Twitter. It seemed relentless... and unending.

And yet every single session was different and moved us internally as we realized that we still could not move externally.

Now December ends, the vaccine is here.

Or is it? The amazing thing is how reluctant many people are to get the vaccine. They are more reluctant to get the humanly transformed viral RNA than COVID-19 — the thing itself.

It really saddened me to hear that some of my patients wanted to wait. Wait for what?

I first thought they want this lockdown to go on in some way, and I considered that they have gotten used to this form of contact, but as Elton John sings, "But then again, no."

I think it is a panic of retransforming, of meeting personally once again and really feeling the loss of this year.

A lot of my colleagues dropped the distant practice and decided to meet patients physically.

I know that if I persist with the *possibility* of online work, the comeback will be more difficult because the loss is all that more deeply to be felt.

After the summer break, I decided to open my consulting room to meet patients but incorporate distance and wearing a mask. I didn't stress on it in any way.

Some patients came to see me and let me "see" them. I will end on a sad note. You see, in retrospect, I don't consider these sessions as having any particular analytic value.

Though this sounds sad, I think until both parties are unmasked and able to be safely close physically, these meetings are rather a break from the drama and from the dream of floating in space. But we are still without a safe chance to land our ship on a Mother Earth where the storms have subsided. ▪

Love Poem in the Shape of a Dream

trying to sense where things really stand
from the shadows cast in the suffering

You had a theory about what happened
and came to me in a dream to stand by me
when I was wrong and damned and yet
completely innocent. Trying to sense
where things stand from the shadows
cast in the suffering:

Such was your loyalty, friend, and you
kissed me when it could make a difference.
You said I was mean and cruel
and it was only just what had happened,
For snark and meanness protect
the sweet and vulnerable heart,
weary from figuring it all out on its own.

And you came to me in a dream
and I don't even know if you know that,
wherever you are in heaven or hell,
and you kissed me when it could make a difference.
I try to remember what that felt like,
the sort of loyalty that stays.
I look at the shadows of love stretching
long onto the empty pavement glistening in the heat.

If I can find a way through all
these myriad felt and mostly
scorned and disreputable worlds,
I will stand by you too,
and kiss you when it can make a difference.

DONATE!

MAKING MORE *ROOM* TOGETHER IS

COMMUNITY *ACTION*

ROOM provides a platform for psychoanalysts to reflect on current issues in addition to bringing the voices of recognized writers and artists to new communities. *ROOM* is also proud of the editorial support we provide to individuals who have never published or lacked confidence in their abilities to communicate. *ROOM* gives space to authors and artists who have not had opportunities to express themselves because of political limitations in their own countries. The need to continue to interpret current events has only grown. The success of our mission is only possible through community involvement and support. Please continue to make *ROOM* possible. No amount is too small; everything is appreciated and needed.

For more information:
analytic-room.com/donations

or **SCAN** with your smartphone

C. Jama Adams

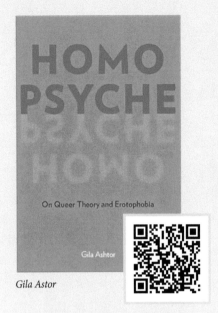

Gila Astor

Sheldon Bach

Daniel Benveniste

Joseph A. Cancelmo

Coline Covington

Michael A. Diamond

Carolyn S. Ellman

Jill Gentile

Adrienne Harris

Jane Lazarre

Kerry L. Malawista

Arnold D. Richards

Jared Russell

Aneta Stojnić

David Stromberg

Isaac Tylim

Kaja Weeks

IPTAR Candidates Organization Fundraiser Challenge

Between November 17th and December 20th, 2020, IPTAR Candidates Organization invited the community to join a 5K Run/Walk/Bike campaign, with the goal of helping fund another year of making *ROOM: A Sketchbook for Analytic Action*. We are deeply grateful for their support.
Stay tuned for a new edition!

Moving into new spaces, especially during this hard time, feels crucial.
— *Marissa Dennis*

ROOM is a space for many voices to be heard.
— *Phyllis Beren*

I want to support this forum.
— *Natasha Kurchanova*

I run for ROOM because this is a ROOM we understand and wish to nourish as we continue to believe in the values of our psychoanalytic training.
— *Jayne Eckley*

I run for ROOM to create a space to help people think in difficult times.
— *Anthony Weigh*

We need ROOM especially in these times!
— *Eva Atsalis*

ROOM is a necessary platform for collective healing.
— *Patrice Rankine*

It's important to stay connected now more than ever!
— *Lea Schupak*

Scan to Donate!

CONFERENCE

THE INTERSECTION OF GENDER, SEXUALITY, AND OUR CURRENT CRISES: THE PSYCHOLOGICAL IMPACT OF RACE, POLITICS, ECONOMICS, AND COVID

FEATURED SPEAKERS

CLAUDIA RANKINE
MACARTHUR FELLOW AND AWARD-WINNING POET

FRANCISCO GONZALEZ
SAN FRANCISCO ANALYST

**APRIL 9, 2021
4:00-6:00 PM EST
APRIL 10, 2021
11:00 AM-6:00 PM EST
LIVE, VIA ZOOM**
(8 CE/CME CREDITS)

Co-sponsored by the Contemporary Freudian Society, the International Psychoanalytical Association, and the American Psychoanalytic Association

For more information, visit:

contemporaryfreudiansociety.org

SCAN with your smartphone to download the Conference PDF

JOIN US!

We are pleased to invite you to

ROOM ROUNDTABLE VIA ZOOM

Join us on March 28 at noon for the Room Roundtable. Bandy Lee, Betty Teng, Raynell Sangster, and Paula Coomer will offer their thoughts about what it means to see each other in a spirit of radical openness. Building from their pieces in the magazine, where they write about politics, clinical work, and personal identity, they will invite us to approach this question from divergent perspectives.

Registrants will receive a Zoom invite. We hope to see you with us.

To receive the invitation, please join our mailing list by visiting:

analytic-room/subscribe

Roundtable Organizing Committee

Elizabeth Cutter Evert
Richard Grose

SCAN with your smartphone to join our mailing list and receive *ROOM* invitations and updates.

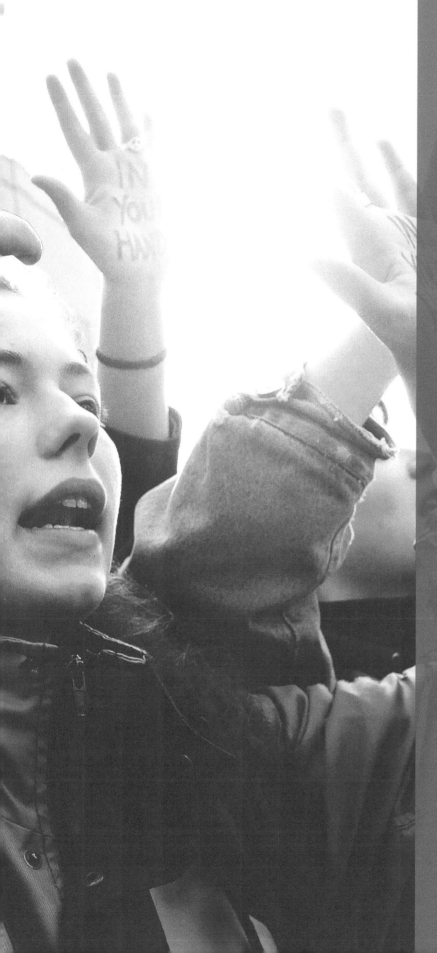

ROOM: A Sketchbook for Analytic *Action* promotes
the dialogue between contributors and readers.
ROOM's first issue was conceived in the immediate wake
of the 2016 US election to be an agent
of community-building and transformation.
Positioned at the interface between the public
and private spheres, ROOM sheds new light
on the effect political reality has on our inner world
and the effect psychic reality has on our politics.

 CPSIA information can be obtained
at www.ICGtesting.com
Printed in the USA
LVHW070236290321
682796LV00003B/18

* 9 7 8 0 5 7 8 8 8 5 0 6 3 *